THE COLLARS *of* RBG

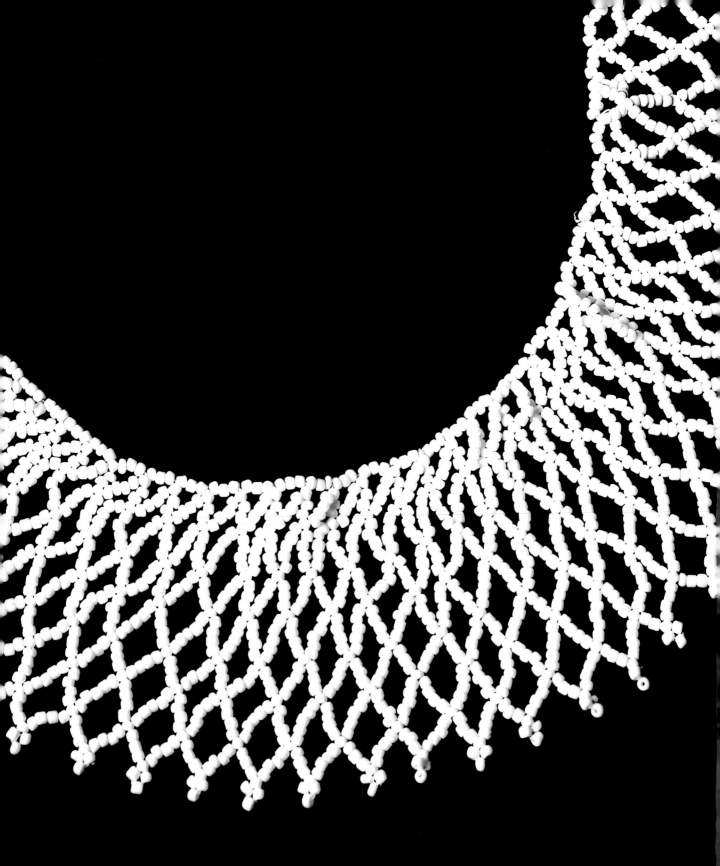

THE COLLARS *of* RBG

A Portrait of Justice

Elinor Carucci and Sara Bader

CLARKSON POTTER/PUBLISHERS

NEW YORK

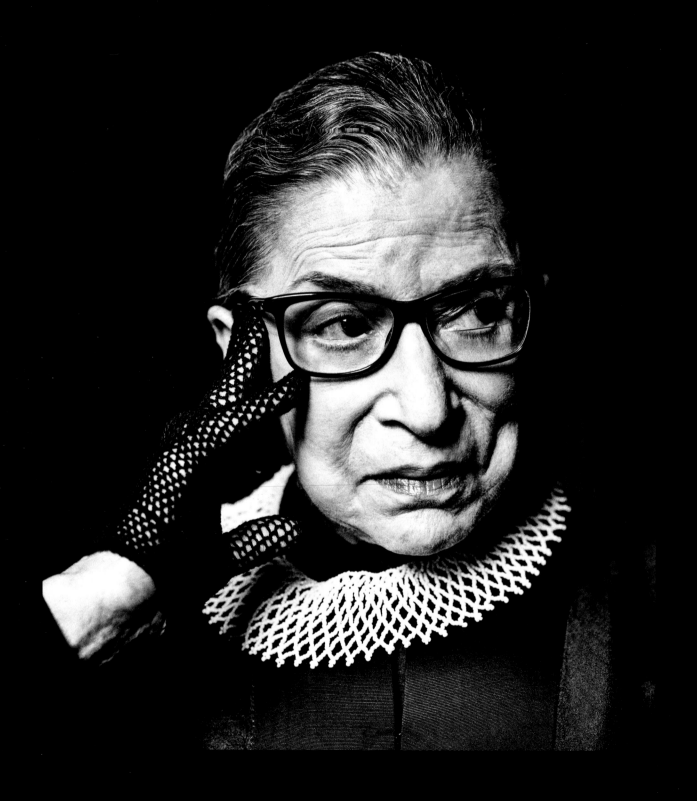

Contents

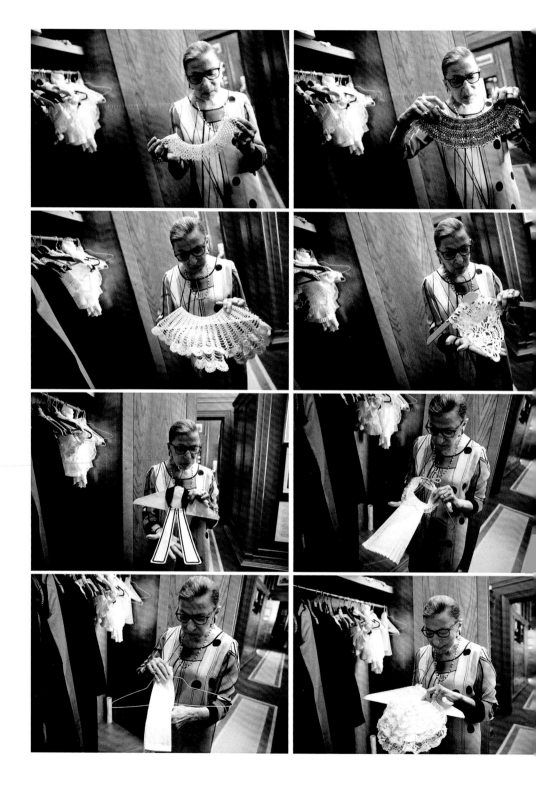

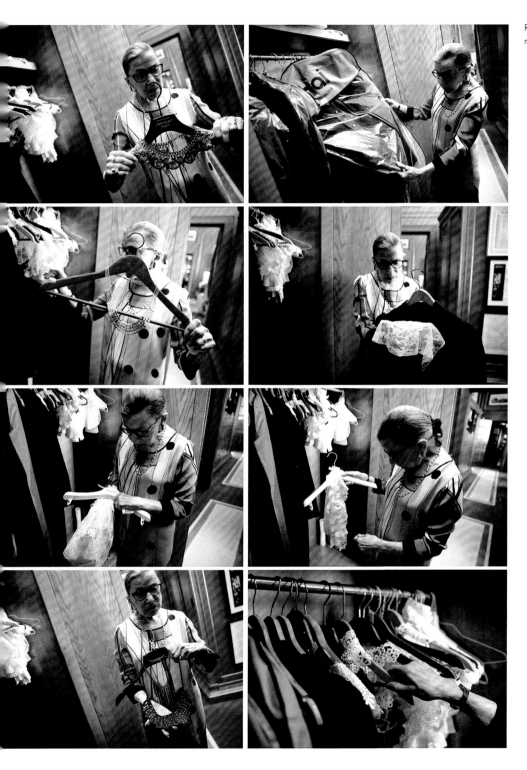

RBG shares a selection of her many collars and jabots, June 2016.

May we be heads, not tails,
Rosh Hashanah (ראש השנה)
evening, 2021.

The Assignment
of a Lifetime

ON SEPTEMBER 18, 2020, we were visiting my aunt Esther in Kew Gardens, Queens, for Rosh Hashanah (ראש השנה) when we heard about the passing of Ruth Bader Ginsburg. My sixteen-year-old daughter, Emmanuelle—a queer, hard-core feminist and mountain of emotions—could not stop crying. Even though we knew that Justice Ginsburg was eighty-seven years old and battling pancreatic cancer, we were shocked. We thought she would live forever.

Emmanuelle cried on the F train home, all the way from Queens to our stop at West Twenty-Third Street in Chelsea. I tried to comfort her. We talked about how Justice Ginsburg touched so many aspects of our lives—as Jews, women, New Yorkers, feminists, and fighters for the issues we care about deeply: LGBTQ+ rights, gender and racial equality, and reproductive and parental rights. Justice Ginsburg's words— "Women will have achieved true equality when men share with them the responsibility of bringing up the next generation"— were raised in discussions with my husband and children.

Justice Ginsburg was a daughter of immigrants, much like my own children; I moved to New York from Israel in 1995. My husband, also Israeli, joined me shortly after, and our son and daughter were born and raised in New York.

Justice Ginsburg's achievements broke so many barriers. Her story held special significance for Jewish women like myself who dreamed of living a life that combined career success with motherhood—and, in Ginsburg's case, also practicing the principle of *tikkun olam* (תיקון עולם), the Hebrew term for repairing the world.

The week following her passing, I felt an urge to create work inspired by Justice Ginsburg, but I couldn't find the right approach. Much of my personal photographic work has

revolved around intimacy, family, motherhood, and women—how would I capture the legacy of a personal hero? Then I was approached by Katherine Pomerantz, *Time* magazine's photography director, about the possibility of photographing the justice's collars for the magazine, and it felt like a prayer was being answered. This assignment was the equivalent of documenting a superhero's costume, with all of the significance Justice Ginsburg held for me, my family, and millions of other Americans.

The assignment was still-life photography, not my specialty. Katherine believed as an artist, woman, mother, feminist, and Jew, I was the right person for this project, but I questioned whether I was the right photographer. In a conversation with Katherine, I shared the strong connection I felt to Justice Ginsburg's legacy, and I listed every still-life photograph I'd ever created, from my grandmother's Bukharan cooking to my mother's beautiful red nails, and even images of my own uterus after a hysterectomy for a series about approaching midlife as a woman. After Katherine gave me the assignment, I ran to my daughter's room and we burst into screams of joy.

As conversations about my fast-approaching trip to Washington, DC, progressed, I gathered my technical ideas about how best to photograph these meaningful objects. I talked with Katherine about creating full images of each collar and then zooming in on the details, as if taking a journey into each intricate design and the story it told. There was a lot to consider technically: camera angles, lenses, lighting, props, even how much time I would have to shoot each of the collars in the Supreme Court's collection. I collaborated with prop stylist Josefine Cardoni to create semimatte velvet backgrounds for the shoot. Josefine stretched a rich black velvet that resembled the material used to line the drawers of jewelry boxes over two large wooden boards for me to take to Washington. I asked my husband, Eran, a fellow graduate of the photography program at Bezalel Academy of Arts and Design in Jerusalem, to help me on the shoot. The assignment was now a family affair.

It was important for me to do my own research before the shoot. I studied photographs and videos of Justice Ginsburg to familiarize myself with the varied materials and colors of the pieces. I learned that Justice Ginsburg initially started wearing these collars to represent her female identity and to distinguish herself from the male justices. Poring over the images and footage, I hoped to sense if she had a favorite or if certain collars held special significance.

I hardly slept the night before Eran and I drove to DC. There was so much to think about. I had six minutes to shoot each collar and needed the lighting, exposure, and composition to be perfect. There was no room for miscalculation. When we arrived at the Supreme Court and went through security—the sniffing dogs, the whole deal—my heart was pounding. This was the highest court in the land, where life-and-death decisions are made, and where the justice spent the last twenty-seven years of her professional life. As an immigrant, I felt a sense of pride; I came to America from another country, and now I was taking photographs in the Supreme Court.

We waited for the arrival of the collars in the formal and expansive East Conference Room. Tyler Lopez, the staff assistant at the Public Information Office, told us stories about Justice Ginsburg's days with the court's employees and her unlikely friendship with the late justice Antonin Scalia. In such divisive partisan times, their friendship was an inspiration. My arrival at the Supreme Court also coincided with the first day of conservative justice Amy Coney Barrett, Justice Ginsburg's replacement. The significance of this timing was not lost on me.

A set of drawers was rolled into the room, accompanied by a delegation of staff, and the conference room was silent. We felt the presence of the collars. Each velvet-lined drawer held a small object with immense meaning. I felt like I was diving into the history of RBG's tenure and every collar represented a story, a memory, a dissent, or a momentous opinion that changed the course of American history.

I got to work.

I carefully unwrapped the velvet boards Josefine had stretched for the shoot and set one up in my designated space on one side of the room. I opened two strobes: one with a softbox and a grid, to give off diffused light; the other with a beauty dish and a honeycomb grid, to give off more

"The standard robe is made for a man because it has a place for the shirt to show, and the tie. So Sandra Day O'Connor and I thought it would be appropriate if we included as part of our robe something typical of a woman. So I have many, many collars."

contrasted light that would highlight the collars' colors and textures. I set up a small ladder that would allow me to photograph from above and prepared the lenses: a telephoto 70mm for the full images of the collars and a macro 100mm lens for detailed close-ups. Eran and I positioned the lights, tested the exposure, and shot some tests using a handmade paper collar we had fashioned in the shape of Justice Ginsburg's favorite piece, from South Africa.

Eran has been assisting and supporting my photography since we first met in 1993, when we were both photography students. We have worked together on hundreds of photo shoots since—personal, editorial, commercial. Working together is like a dance: we are connected, attuned, synced. We worked quietly, nervously, and quickly. Focused, as the team we know how to be. Wearing white cotton gloves, we gently lifted each collar or jabot out of its drawer and placed it on the black velvet, spending six intimate minutes with each historic artifact before returning it to its drawer.

As I carefully set up each shot, I admired the beauty and style of each object. I had seen Justice Ginsburg wearing some of these collars in the news photographs and TV footage I'd studied, but appraising her personal treasures up close was an entirely different experience. I felt like a teenager visiting a museum for the first time to stand in front of my favorite Van Gogh or Chagall painting. I was transported to stages of Justice Ginsburg's life: moments when she dissented, fought for what she believed in, shared personal stories with other justices, looked into the eyes of her beloved Marty, or held her children, Jane and James. I was granted extraordinary access into the heart and mind of one of the world's most admired women, someone who had a maternal way of bringing about change, with patience and great respect for the opinions of the other side.

It felt right—to be there at the Supreme Court, photographing the collars in the place where Justice Ginsburg had worn them many times. To be working with my husband and not with a team of assistants. To use the same lights, camera, and lenses I have been using for years to document my children, husband, and parents, photographing the close-ups of my body and my mother's body; close-ups of my grandmother's and my mother's jewelry, makeup, and Bukharan dishes.

The photographs of RBG's collars are very different from my most known work, as collected in my books *Closer* (2002), *Mother* (2013), and *Midlife* (2019), in which I draw from the deepest and most intimate parts of my life and the microcosm of family relationships. Justice Ginsburg is not a family member. I never met her in person. Yet this series of photographs is deeply personal. She was a symbol of justice and pride, my superhero. She represented my identity and connection to America. She represented the values I hope to pass on to my daughter and son, American Jews and the children of immigrants. I went into this shoot determined to do my finest still-life photography and left feeling that I did what I have always done with my camera: I created a portrait. It was not so different from the work I've created over the last three decades about the layered experience of being human; about family and motherhood; about love, passion, and commitment; about emotions, struggle, and success; about morals, pain, and sacrifice. And though Justice Ginsburg herself was never in the frame, her presence and legacy found their way into my images through those collars.

Eran and I drove back to New York in the dark. We were quiet. We both felt like we had spent the day with Ruth Bader Ginsburg and we didn't want to break the silence or the tenuous magic of that feeling. We wanted to hold on for as long as we could.

Elinor Carucci

New York City, 2015.

DISTINGUISHED

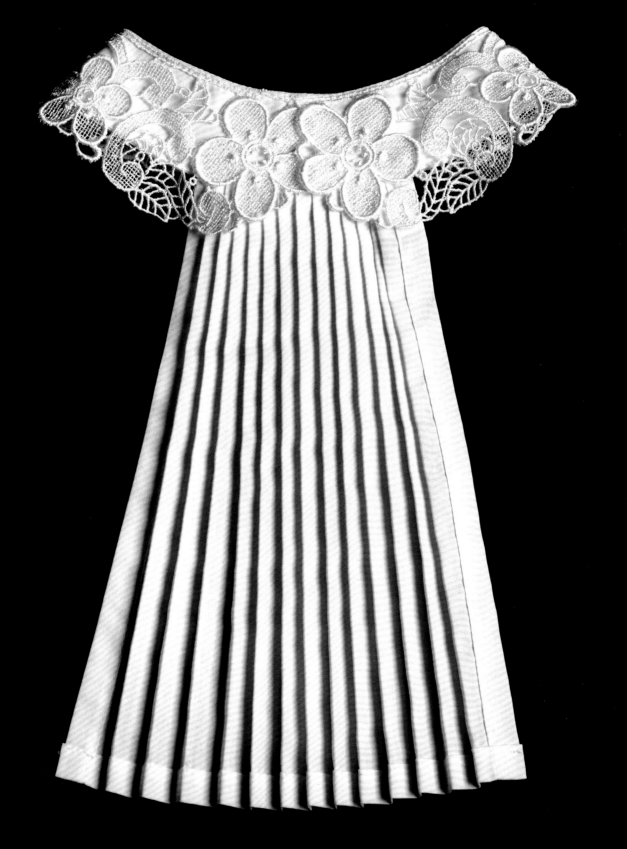

WHEN JUSTICE RUTH BADER GINSBURG took her seat on the Supreme Court bench on August 10, 1993, she became the second female to serve on the country's highest court, joining Justice Sandra Day O'Connor (nominated by President Ronald Reagan in 1981). In the court's group portrait from RBG's first term, the nine justices, posed in front of red velvet curtains, wear flowing black judicial robes. The uniform is a simple but powerful symbol: concealing the individual's body, it conveys impartiality and the somber, collective responsibility to uphold the Constitution. Justices Ginsburg and O'Connor flank the seven male justices.

There isn't a dress code for Supreme Court justices—the black robe has been worn over the years out of tradition. For the seven male justices in this 1993 court photograph, the white button-down shirt collars and ties (and one cheerful bow tie) are distinguishing fashion choices. RBG and Justice O'Connor, meanwhile, set themselves apart from their male colleagues, each adorning their uniform with a traditional white jabot— a frill of lace or other type of fabric fastened at the neck and worn over the front of a shirt or robe. Their colleagues overseas inspired this sartorial accent—barristers in England have long worn jabots, along with gowns and wigs, as part of their customary courtroom attire. French magistrates wear jabots as well, known there as rabats. Lace was considered a marker of wealth and status, not gender, from its origins until the late eighteenth century, and lace neckpieces, such as jabots and rabats, were traditionally worn by men. It is worth noting that although Justices O'Connor and Ginsburg accessorized their robes with jabots and collars that were seen as feminine in our time, they were appropriating what was once a symbol of masculine power. Purchasing jabots in the United States, though, proved challenging: "Nobody in those days made judicial white collars for women," Justice O'Connor remembered. "I discovered that the only places you could get them would be in England or France."

Their decision to feminize a traditionally male uniform was a radical one. By wearing these decorative accessories, both Justices O'Connor and Ginsburg communicated that a woman could be both intellectually rigorous and feminine. "[Ginsburg's] collars re-inject the concept of 'body' into the disembodying judicial robe," notes author Rhonda Garelick, "signaling not only the presence of a woman, but by extension, the presence of a biological human body—which demands acknowledgment and consideration."

This jabot, although more decorative, is reminiscent of the one RBG wore in that first group photograph and in her earlier years on the Supreme Court. The lace collar—with its modern rounded flower petals, leaves, and scrolls—offsets the formality of the crisp, pleated form. Over the years, RBG's collection of neckpieces expanded considerably in number and style, from classic white jabots like this one to intricate lace pieces to vibrant beaded collars. She acquired some in her travels, and cherished those gifted to her by colleagues, artists, and fans from all over the world.

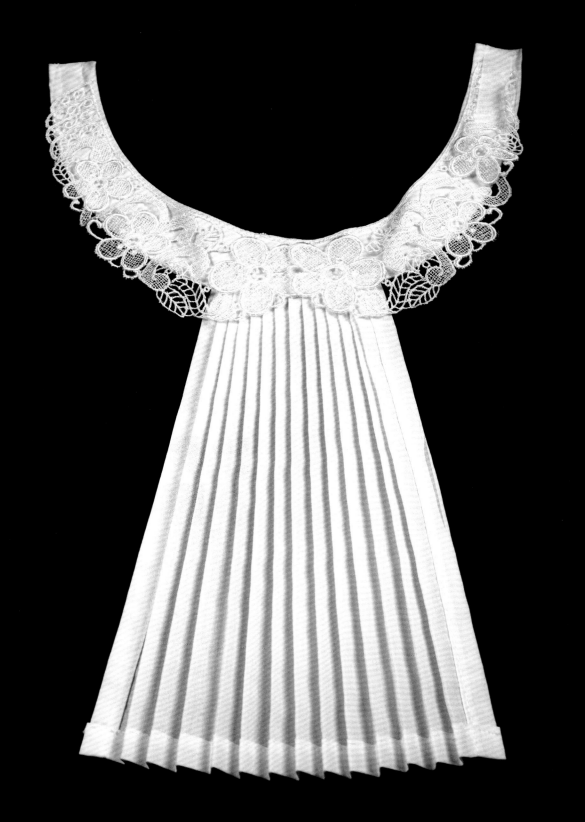

"If I am notorious, it is because I had the good fortune to be alive and a lawyer in the late 1960s. Then, and continuing through the 1970s, for the first time in history, it became possible to urge before courts, successfully, that equal justice under law required all arms of government to regard women as persons equal in stature to men."

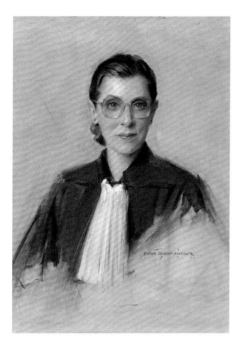

Everett Raymond Kinstler,
Ruth Bader Ginsburg, 1996.
Oil on canvas.

Supreme Court group portrait,
1993, RBG's first year on the
bench.

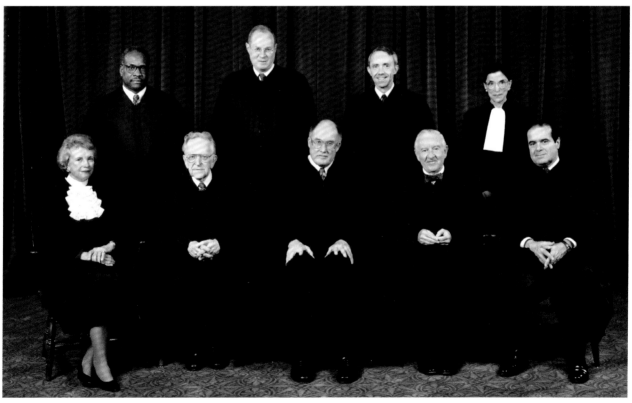

"My advice is fight for the things that you care about. But do it in a way that will lead others to join you."

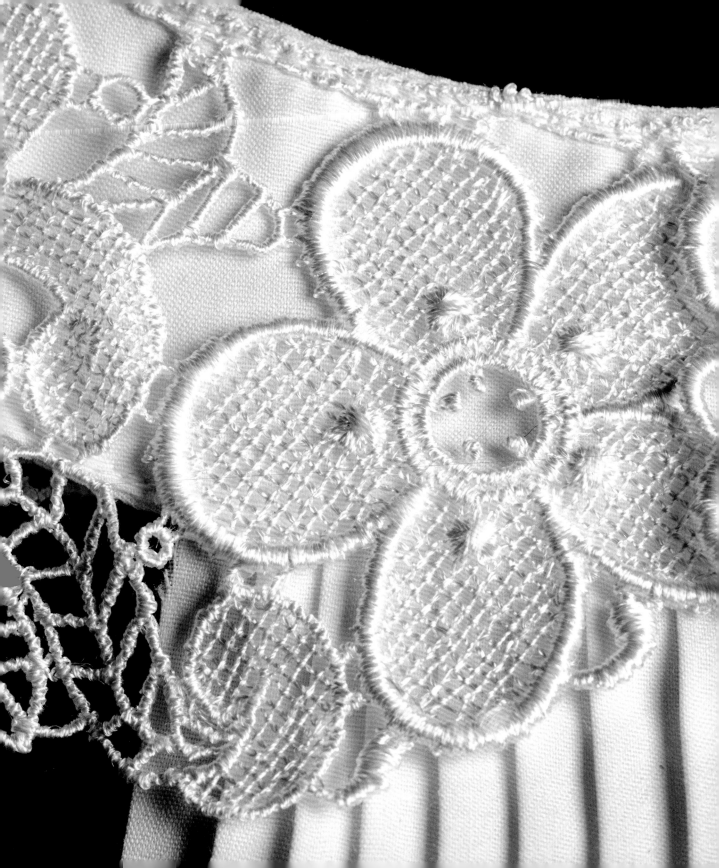

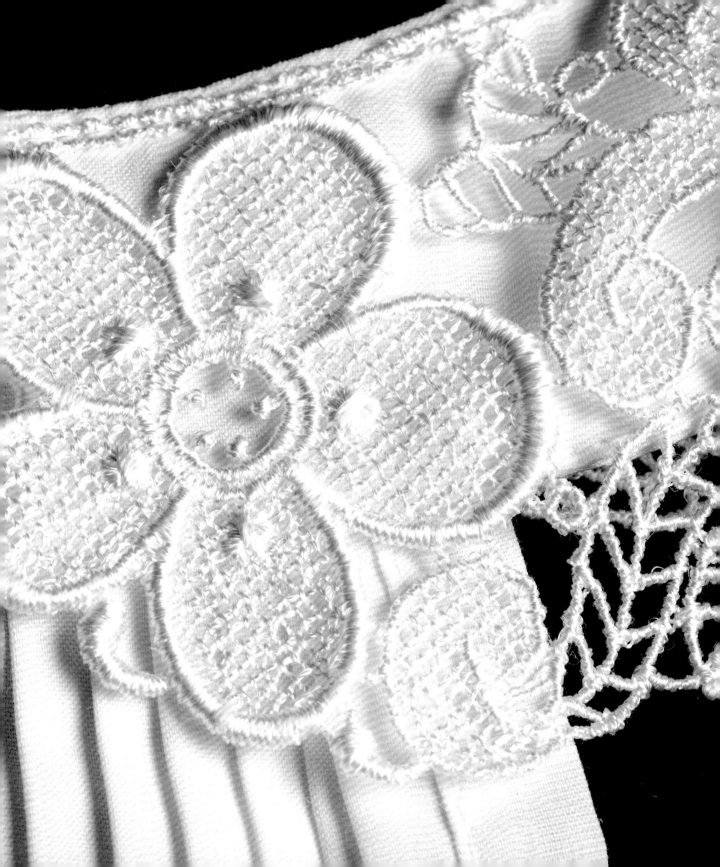

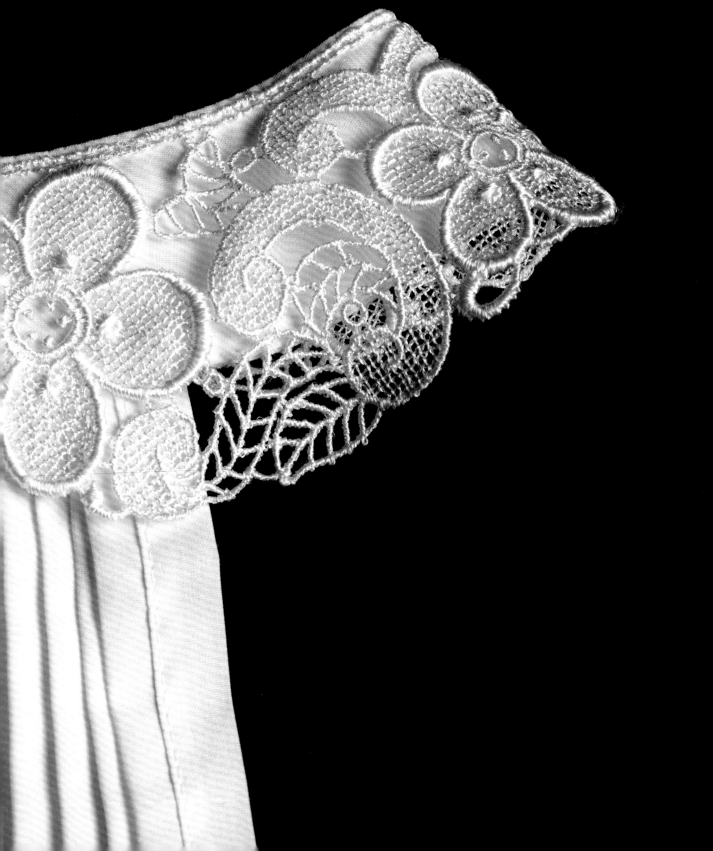

"Indeed, in my lifetime, I expect to see three, four, perhaps even more women on the High Court Bench, women not shaped from the same mold, but of different complexions. Yes, there are miles in front, but what a distance we have traveled from the day President Thomas Jefferson told his Secretary of State: 'The appointment of women to [public] office is an innovation for which the public is not prepared. Nor,' Jefferson added, 'am I.'"

LACE

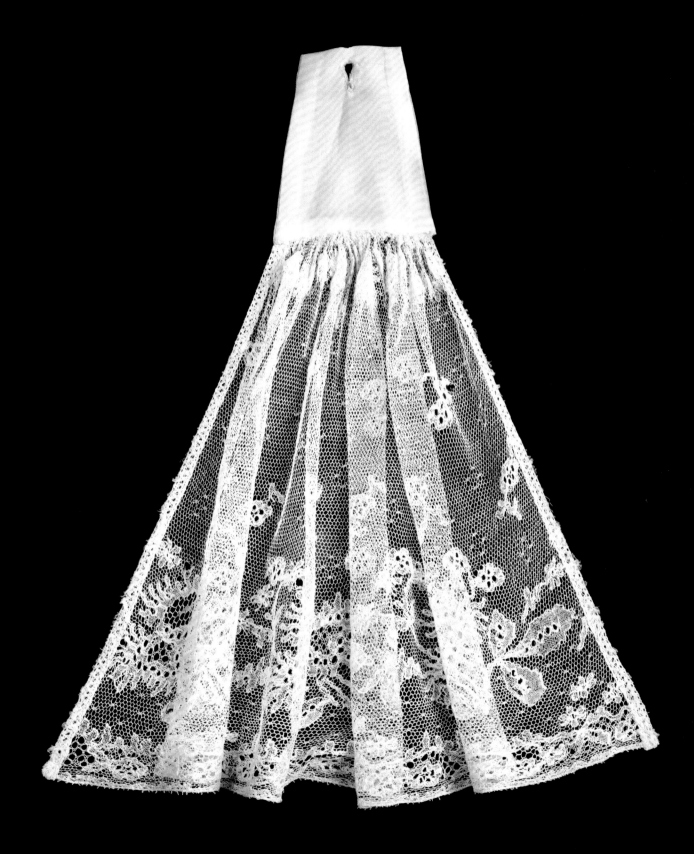

IN A PORTRAIT PAINTED by artist Simmie Knox in 2000, a lace jabot cascades from the neck of RBG's black robe. Justice Ginsburg often wore this formal jabot for portraits and ceremonies—it adorns her black robe in Supreme Court group photographs in 2003, 2009, and 2010.

"Lace is complicated to make, and even more complicated to truly understand. It's always been a medium of contrasts and extremes," describes fashion historian Elena Kanagy-Loux. Lace originated in northern Italy in the early sixteenth century and became a symbol of wealth, power, and influence in Europe. Although women excelled at the art of lacemaking—a painstaking skill that requires tenacity, artistry, and tremendous patience—they rarely kept the profits and typically remained anonymous. Lace was considered a luxury textile and cost a small fortune; the price of one piece could exceed the yearly salary of the lacemaker who made it.

Queen Elizabeth I passed sumptuary laws that prohibited lower social classes from wearing lace. Similar laws carried over to the American colonies: in Massachusetts, in 1651, for example, if your estate was valued at less than two hundred pounds, you were prohibited from wearing "any gold or silver lace, or gold and silver buttons, or any bone lace above 2 [shillings] per yard, or silk hoods, or scarves, upon the penalty of 10 [shillings] for every such offense."

RBG's decision to adorn an otherwise generic, stark black robe with a lace jabot connected her to the legacy of the undervalued women who devoted their time to a spectacularly complicated textile art. Typically perceived as frilly, fragile, and delicate, densely worked linen lace can be the opposite: remarkably sturdy and tough—an apt symbol for a small-statured, quiet woman who has been described as "a warrior for justice" and "a rock of righteousness."

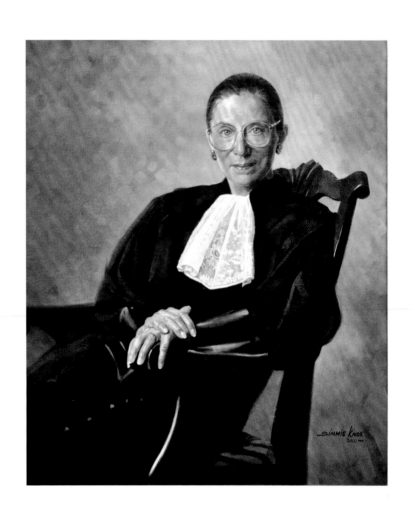

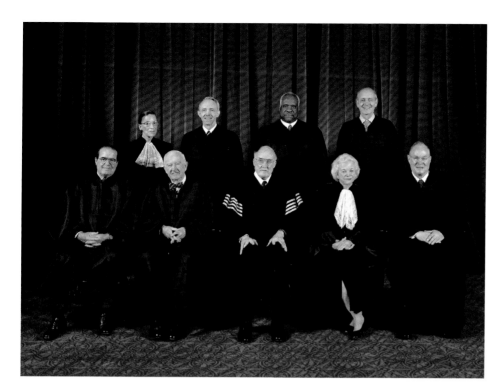

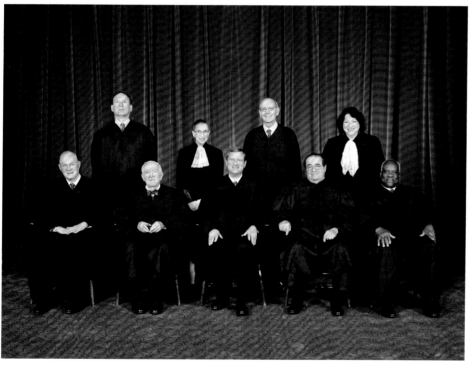

Supreme Court group portraits, 2003 (top) and 2009.

OPPOSITE: Simmie Knox, *The Honorable Ruth Bader Ginsburg,* 2000. Oil on linen.

The judiciary is not a profession that ranks very high among the glamorously attired. . . . Taking a cue from our colleagues abroad, Justice O'Connor and I broke the plain black monotony by wearing a variety of lace collars, and we also added sewn-in pockets. Not very long ago the only way to distinguish the justices, at least in appearance, was to separate the bearded from the close-shaven. Is it not . . . a wonderful sign of progress that three women now serve on our Supreme Court, and no one confuses me with Justice Sotomayor or Justice Kagan?"

MAJORITY

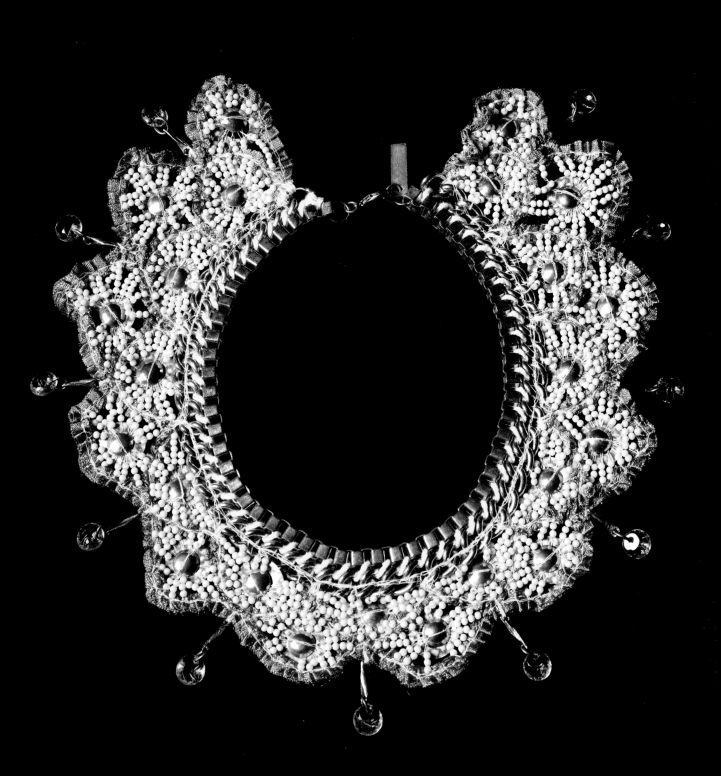

IN 2016, Justice Ginsburg's law clerks gave her this gold beaded collar with small, delicate pendants and a rose-scalloped trim. She wore this piece from Anthropologie when announcing some majority opinions. Over the course of her tenure on the Supreme Court, she wrote more than two hundred majority opinions for the court. She authored one of her most legendary opinions—joined by Justices William Rehnquist, John Paul Stevens, Sandra Day O'Connor, Anthony M. Kennedy, David H. Souter, and Stephen G. Breyer—for the 1996 case *United States v. Virginia*, in which the Supreme Court ruled that denying women admission to the all-male Virginia Military Institute violated the Equal Protection Clause of the Fourteenth Amendment.

Justice Ginsburg's writing was clear, incisive, and persuasive. "I go through innumerable drafts," she explained. "I try hard, first of all, to write an opinion so that no one will have to read a sentence twice to get what it means." She credits Vladimir Nabokov, her European literature professor at Cornell during her undergraduate years, for influencing her writing style. "Words could paint pictures, I learned from him. Choosing the right word, and the right word order, he illustrated, could make an enormous difference in conveying an image or an idea."

Justice Ginsburg considered law a literary profession and was devoted to passing on her love of words to her clerks, showing them, through example and through mentoring, the importance of writing with care and precision. After drafting opinions, clerks would print them out in 14-point type, triple spaced, to leave room for her edits. A day or two later, after she had reviewed the text, they would be called back to her chambers. "What we got back looked like a collage: cut-out snippets of white letter paper glued to yellow legal pads, interspersed with blocks of penciled text in the judge's perfect cursive," described former clerk Edith Roberts. "But after every scissoring and glue-sticking session came a sit-down with the judge, when she went through what she had changed and why, explaining each decision and showing us how to write more clearly. Over the course of the clerkship, our marked-up drafts became more white than yellow."

This gold collar is perhaps most associated with her majority opinions, but she also chose to wear it to President Barack Obama's February 12, 2013, State of the Union address, which set the agenda for his second term in office, and to the ceremony of one of the first gay marriages she officiated, the October 2013 wedding of Ralph Pellecchio and James Carter Wernz. Ginsburg had taught Pellecchio at Columbia Law School, in 1975, and they had stayed in touch. She also edited his and Wernz's wedding vows, much like she did when she reviewed his student papers nearly forty years earlier. "I'd send her a draft on it and then she'd send it back," Pellecchio recalled. "It was very meaningful for me."

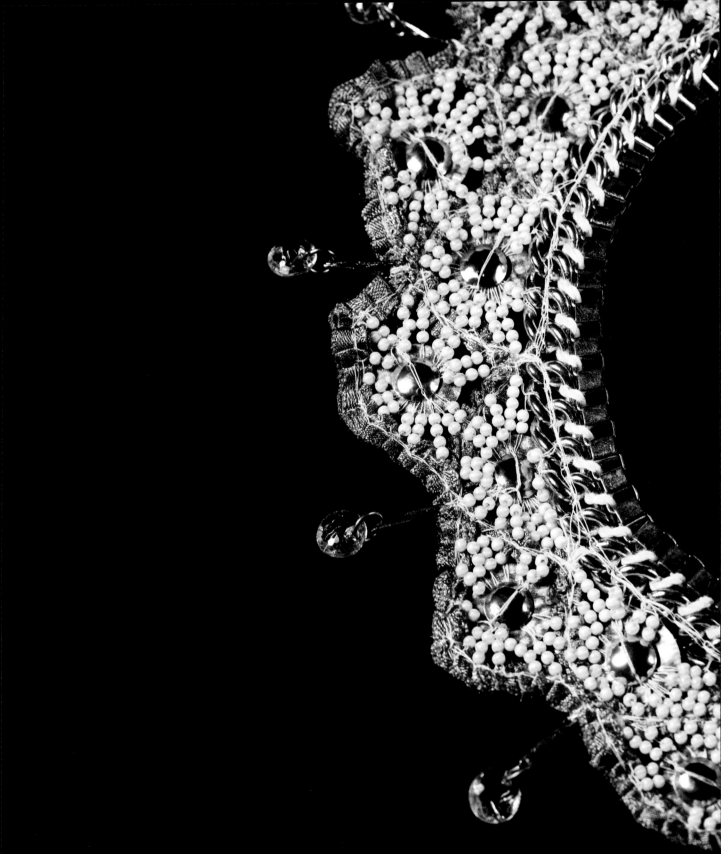

"Any profession has its jargon. The

sociologists have lots of fancy words,

and some of them think somehow that puts

them on a higher plane. I can't bear it.

I don't even like legal Latin. If you can say

it in plain English, you should."

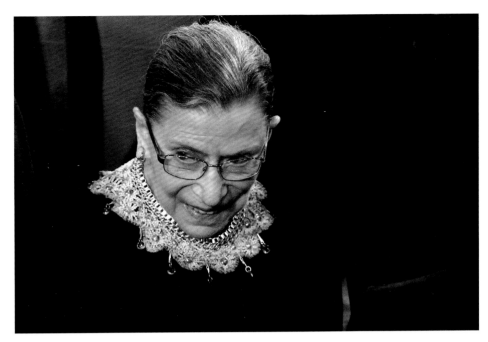

RBG attending President Obama's State of the Union address, February 12, 2013.

RBG pulls out this gold beaded collar from a closet in her chambers, June 2016.

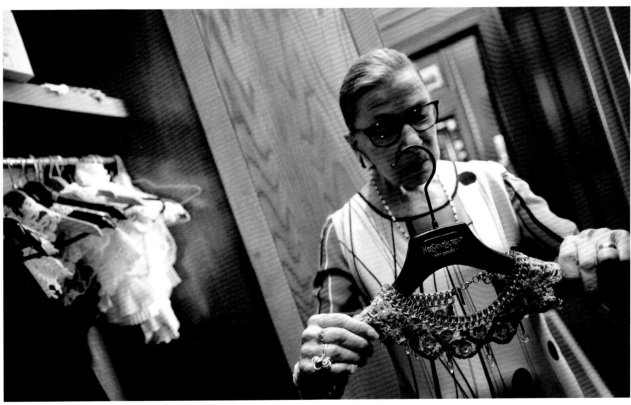

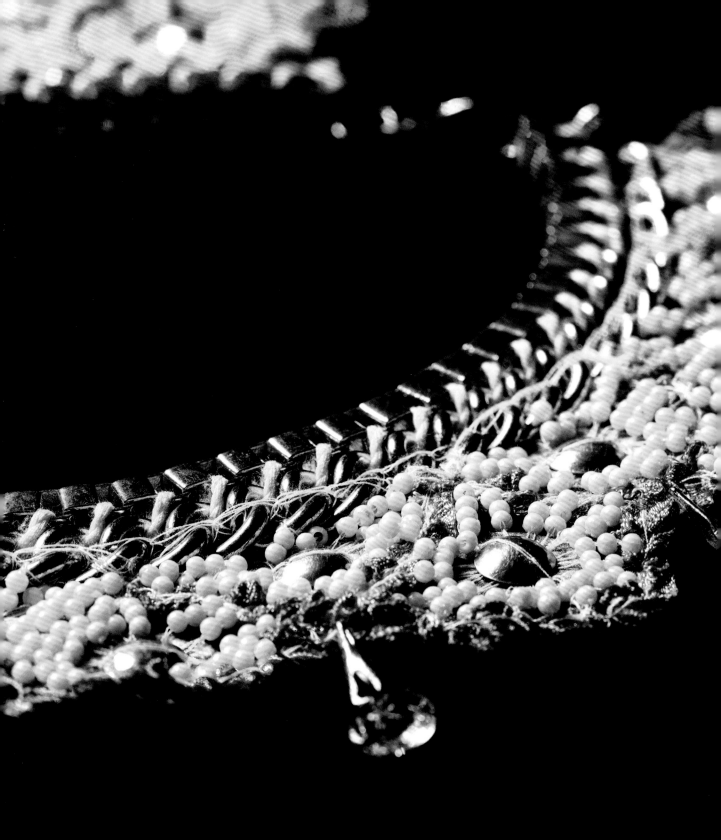

"I think that law should be a literary
profession, and the best legal practitioners
do regard law as an art as well as a craft."

"I prefer and continue to aim for opinions

that both get it right, and keep it tight,

without undue digressions or decorations

or distracting denunciations of colleagues

who hold different views."

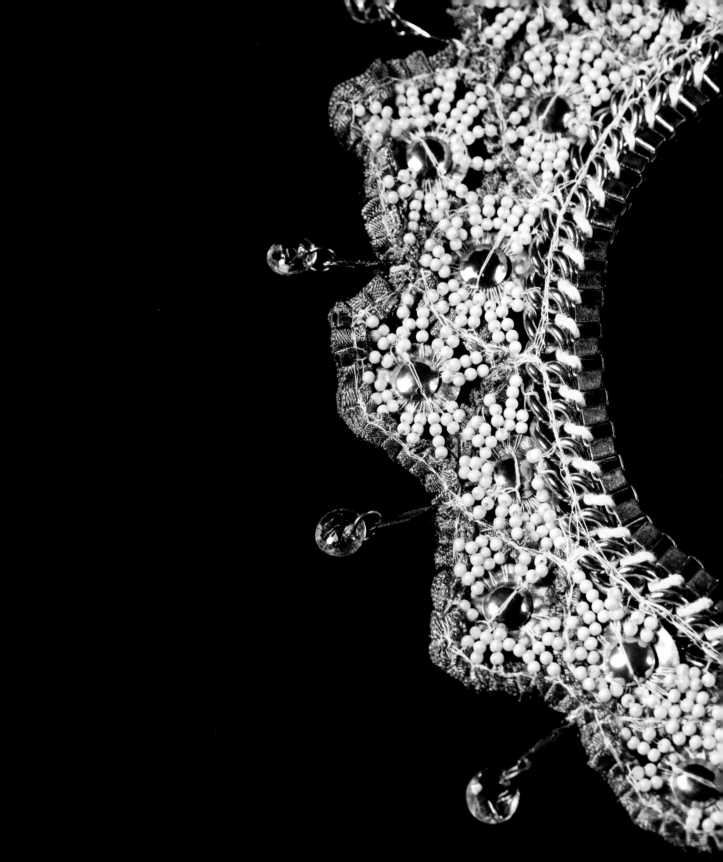

DISSENT

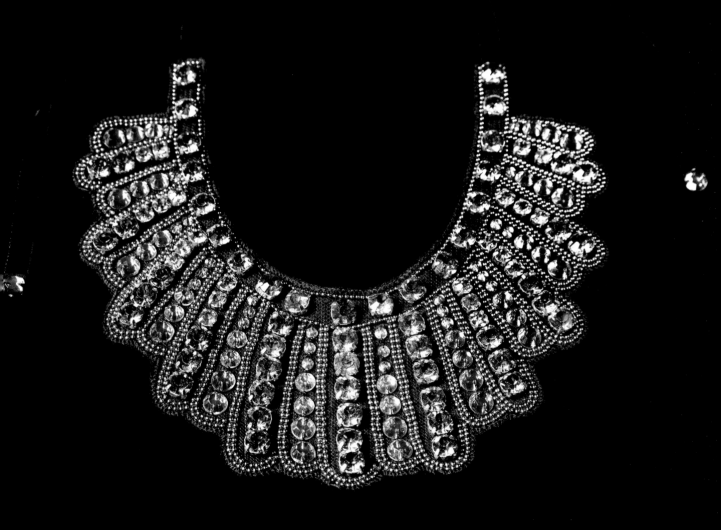

"THIS IS MY DISSENTING COLLAR," RBG told Katie Couric in a 2014 interview, referring to a limited-edition glass stone necklace with a velvet tie. "It looks fitting for dissent." Justice Ginsburg received the neckpiece, made by Banana Republic, in a gift bag when she accepted a lifetime achievement award in 2012 at *Glamour* magazine's annual Women of the Year ceremony. A few years later, in an interview with Jane Pauley, RBG elaborated—but just a bit: "This is my dissenting collar. It's black and grim."

Justice Ginsburg was known for writing precise and forceful dissents when she disagreed with the majority ruling. "When a justice is of the firm view that the majority got it wrong, she is free to say so in dissent," she wrote in a 2016 op-ed in the *New York Times*. "I take advantage of that prerogative, when I think it important, as do my colleagues."

Dissents become part of case law alongside their majority opinions, and can be referenced in future cases. In the words of an earlier chief justice of the Supreme Court, Charles Evan Hughes, often quoted by RBG, dissents are meant to appeal "to the intelligence of a future day." RBG's reading of her incisive dissents from the bench increased with frequency over the years, which she attributed to the ever more conservative makeup of the court: "After 2006, the sight of the tiny black-robed justice rising from the bench wearing her 'black and grim' dissenting collar and clutching her papers became a familiar sight," wrote biographer Jane Sherron De Hart. Ginsburg drafted 115 dissents for the Supreme Court— between her first, in 1994, and her last, in 2020. "Every time I write a dissent," she told Bill Moyers in her last interview, "hope springs eternal."

In 2007, when she was the sole female on the Supreme Court—Justice O'Connor had retired the previous year— RBG delivered a sharp dissent in *Ledbetter v. Goodyear Tire and Rubber Company*. In response to the Supreme Court's ruling in a 5–4 decision that an employee cannot sue for pay discrimination under Title VII of the Civil Rights Act of 1964 unless she brings her claim within 180 days of her employer's discriminatory pay decision, she countered with these words: "Four members of this Court, Justices Stevens, Souter, Breyer, and I, dissent from today's decision. In our view, the Court does not comprehend, or is indifferent to, the insidious way in which women can be victims of pay discrimination." She appealed to Congress to correct the mistake made by her colleagues, and two years later Congress followed through, passing the Lilly Ledbetter Fair Pay Act of 2009, the first piece of legislation President Obama signed in office—a copy of which RBG framed and hung in her chambers.

She wrote another forceful dissent for the 2013 case *Shelby County v. Holder*, in which the majority struck down a key section of the 1965 Voting Rights Act, deeming it unconstitutional. RBG did not mince words: "Hubris is a fit word for today's demolition of the VRA [Voting Rights Act]." Under the 1965 Voting Rights Act, certain jurisdictions with a history of discrimination were required to submit any redistricting plans to the US Department of Justice for preclearance before they could make changes to voting procedures; this was the key section at play. Toward the end of her dissent, which was joined by Justices Breyer, Sotomayor, and Kagan, Ginsburg offered this analogy to explain why eliminating the need for preclearance was senseless and shortsighted: "Throwing out

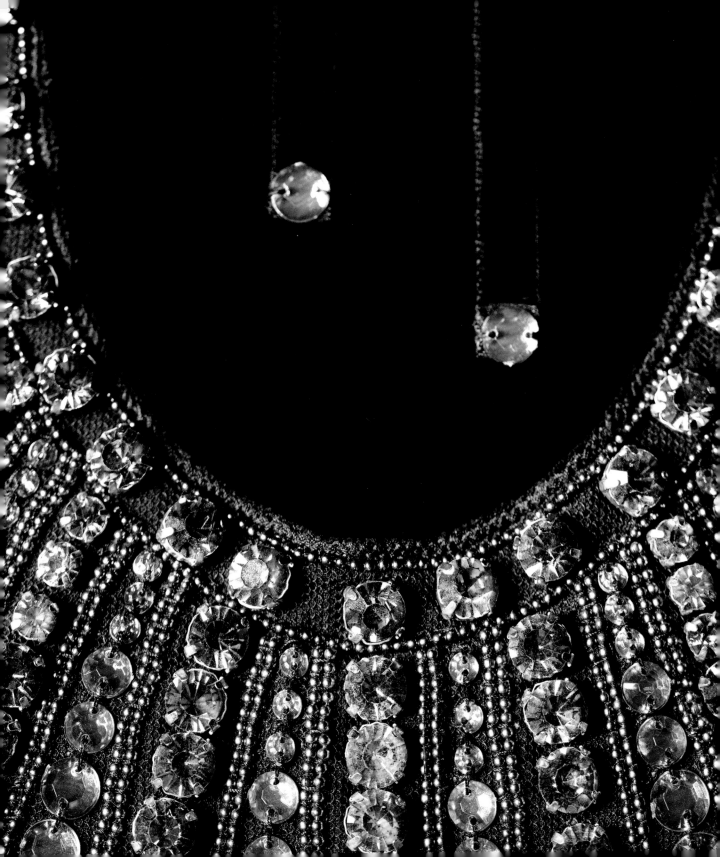

preclearance when it has worked and is continuing to work to stop discriminatory changes is like throwing away your umbrella in a rainstorm because you are not getting wet." According to her biographer De Hart, when RBG read the dissent aloud, she quoted Martin Luther King Jr. His words are not included in the written dissent: "The arc of the moral universe is long, but it bends toward justice." But she clarified that it could only bend toward justice "if there is a steadfast commitment to see the task through to completion," ending with, "That commitment has been disserved by today's decision."

In 2014, she wrote and delivered another eviscerating dissent in response to the Supreme Court's 5–4 ruling in *Burwell v. Hobby Lobby Stores*. The ruling asserted that a corporation cannot be forced to provide its employees with insurance coverage for contraception when doing so violates the corporation's religious beliefs. The decision effectively imposed the company's religious views on its employees. RBG explained that the employers and "all who share their beliefs may decline to acquire for themselves the contraceptives in question. But that choice may not be imposed on employees who hold other beliefs. Working for Hobby Lobby . . . in other words, should not deprive employees of the preventive care available to workers at the shop next door."

She wore the dissent collar in the courtroom but also for significant occasions off the bench, including the day following Donald Trump's election in 2016. Banana Republic reissued the piece in 2019 for a limited time, now called the Notorious Necklace, donating fifty percent of the proceeds to the American Civil Liberties Union Women's Rights Project, which Justice Ginsburg cofounded in 1972. The company reissued it again in 2020, as a tribute to the late justice, this time donating the proceeds until the end of that year, up to a half million dollars, to the International Center for Research on Women.

"Justice Ginsburg's dissents were not cries of defeat," Rabbi Lauren Holtzblatt reminded mourners when she eulogized RBG in the Capitol's Statuary Hall. "They were blueprints for the future."

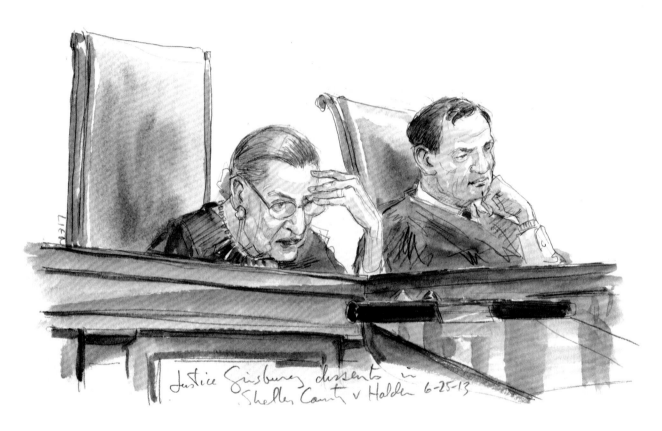

Justice Ginsburg dissents in
Shelby County v Holder 6-25-13

Wearing her "dissent collar" in this
courtroom sketch, *Shelby County v.
Holder,* June 25, 2013.

"My dissenting opinions, like my briefs,

are intended to persuade. And sometimes

one must be forceful about saying how

wrong the Court's decision is."

Dissents speak to a future age. It's not simply to say, 'My colleagues are wrong and I would do it this way.' The greatest dissents do become court opinions and gradually over time their views become the dominant view. So that's the dissenter's hope: that they are writing not for today but for tomorrow."

ORAL ARGUMENTS I

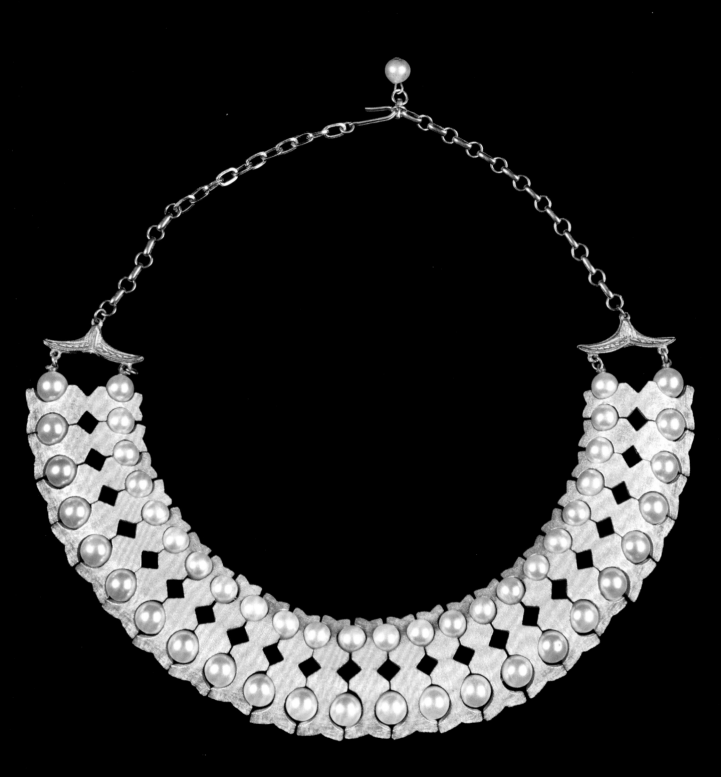

RBG'S LAW CLERKS gave her this neckpiece in 2016, which she wore for oral arguments before 2018.

As a lawyer, RBG argued before the Supreme Court before she became a justice on that bench. She gave her first oral argument before the highest court in the nation on January 17, 1973, in *Frontiero v. Richardson*, a landmark case for gender equality. RBG was advocating for Sharron Frontiero, an air force lieutenant, who was seeking an increased housing stipend and spousal benefits for her husband, a full-time college student. Frontiero's request had been turned down. At the time, members of the military were entitled to "an increased basic allowance for quarters" and health care for their dependents; wives of servicemen were considered dependents, but husbands were considered dependents only if they relied on their wives for more than half of their support. In her oral argument before the nine men on the court—a bench she would join two decades later—RBG quoted women's rights activist Sarah Moore Grimké: "I ask no favor for my sex. All I ask of our brethren is that they take their feet off our necks." The court voted in favor of Frontiero, 8–1.

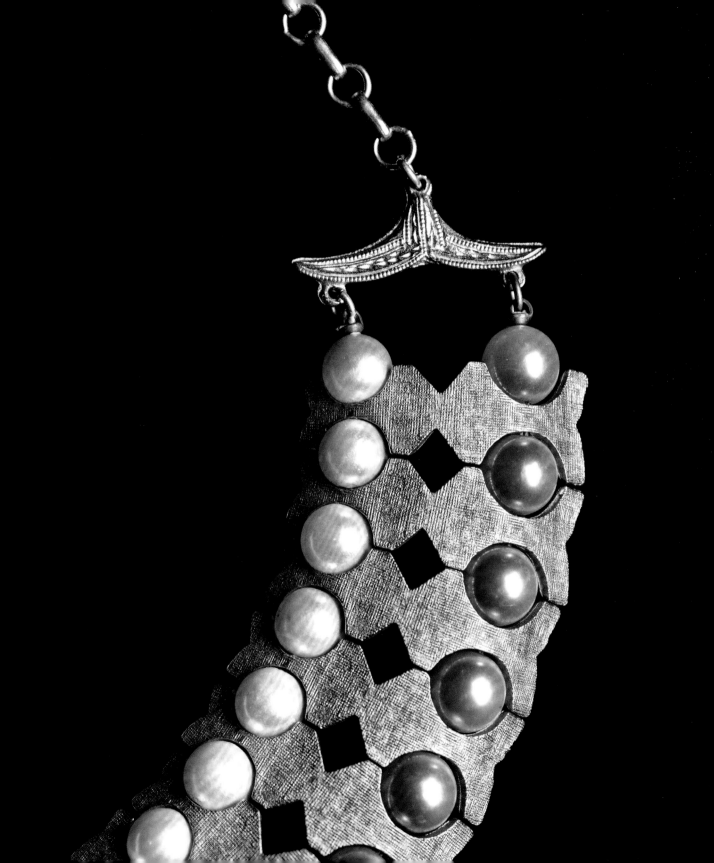

"I owe it all to my secretary at Columbia Law School, who said, 'I'm typing all these briefs and articles for you and the word *sex, sex, sex* is on every page. Don't you know that those nine men [on the Supreme Court], when they hear that word, their first association is not what you want them to be thinking about? Why don't you use the word *gender?*'"

ORAL ARGUMENTS II

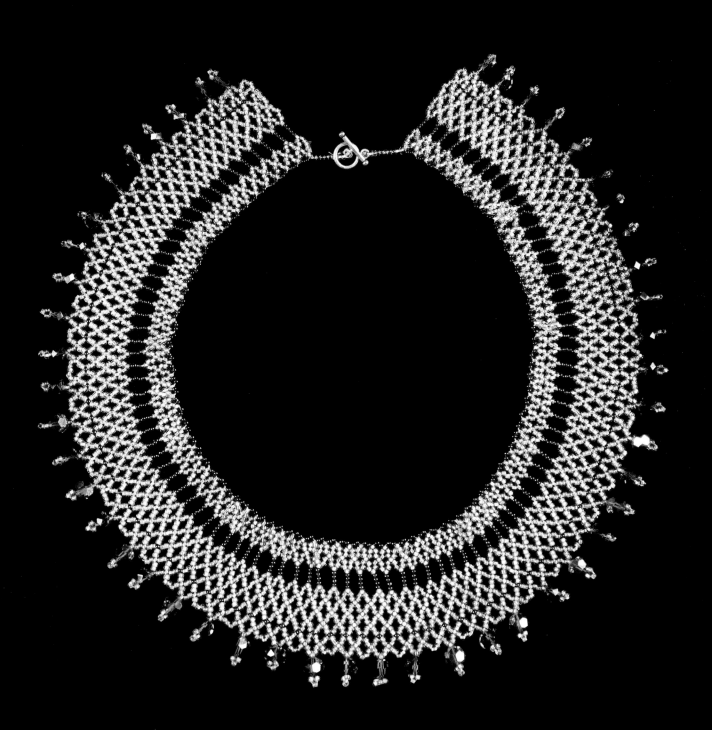

THE ORIGIN OF this delicate purple and gold beaded collar is unknown. RBG received it as a gift in 2018 or 2019 and wore it for several oral arguments.

In 1975, RBG argued *Weinberger v. Wiesenfeld*, a case that exemplified her commitment to fighting gender discrimination for both women and men. The Wiesenfelds lived in New Jersey; Paula was a PhD student, Stephen was starting a computer-based consulting company, and the couple was expecting a baby. On June 5, 1972, their son, Jason, was born healthy, but Paula died during childbirth. A new father and now a widower, Stephen was committed to raising his son full-time during his early years. He went to the Social Security office to apply for survivors' benefits for his son and himself, which a widow would receive, but learned that widowers were not eligible. He wrote a letter to the editor of the *New Brunswick Home News*, explaining the inequality. "I wonder if Gloria Steinem knows about this?" he asked.

The case found its way to Ginsburg at the American Civil Liberties Union. On January 20, 1975, in her oral argument to the Supreme Court, she asserted that this case was "a classic example of the double-edged discrimination characteristic of laws that chivalrous gentlemen, sitting in all-male chambers, misconceive as a favor to the ladies." Two months later, the court voted unanimously in Wiesenfeld's favor, asserting that the "gender-based distinction" in the Social Security Act violated the right to equal protection under the Due Process Clause of the Fifth Amendment.

RBG kept in touch with Wiesenfeld over the years, as she did with so many of her clients: he testified at her confirmation hearing; she married Jason and his wife, Carrie, in 1998; and in 2014, she was the officiant when Wiesenfeld married his second wife, Elaine Harris, in the Supreme Court's East Conference Room.

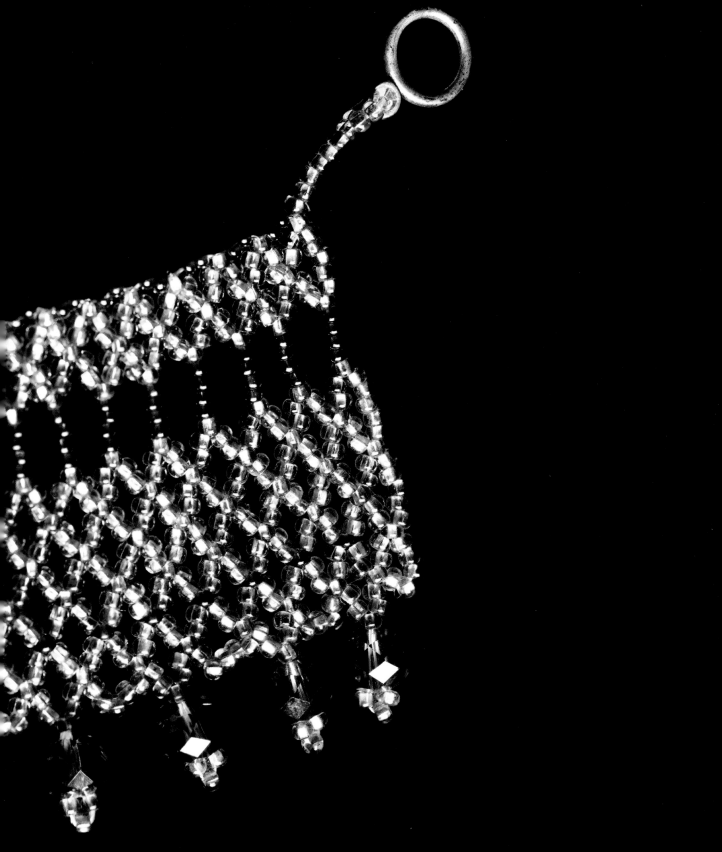

"A skilled lawyer does not dump the

kitchen sink before a judge. She refines

her arguments to the ones a judge

can accept."

I am a feminist? It is true, in the United States, in some quarters, feminism is considered the F-word. But what does it mean to be a feminist, really? It means you believe that society should encompass and embrace all people, women as well as men; that women should have a fair chance to do whatever their God-given talents enable them to do and that they should not be held back by artificial barriers. What is objectionable about that? Most men I know would count themselves feminists. Certainly my spouse did."

SCALLOP

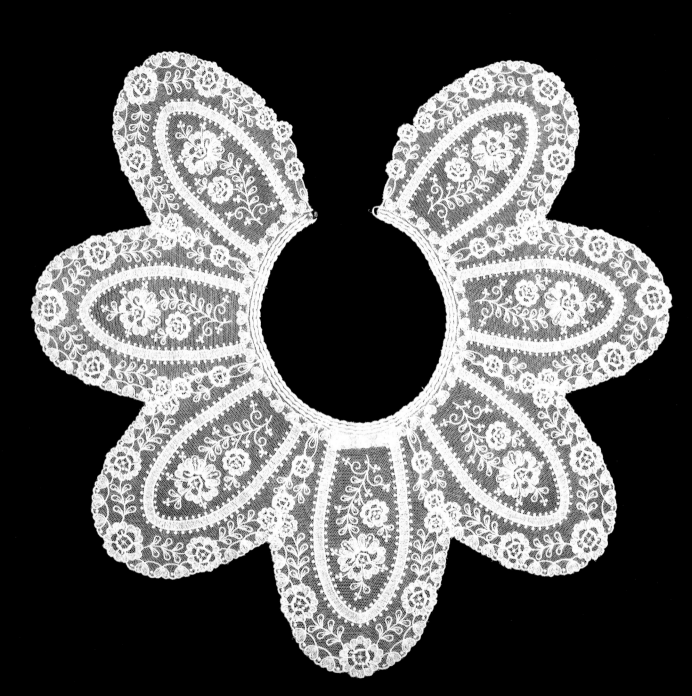

JUSTICE GINSBURG WORE this large, decorative collar on the bench before the pandemic. This type of scalloped-lace collar is reminiscent of styles worn by women in the nineteenth century, when needle arts were practiced by young girls and women. The honeycomb-net ground is embellished with delicate flowers and leaves, dotted bands echo the scalloped design, and a triple row of edgings defines the neckline.

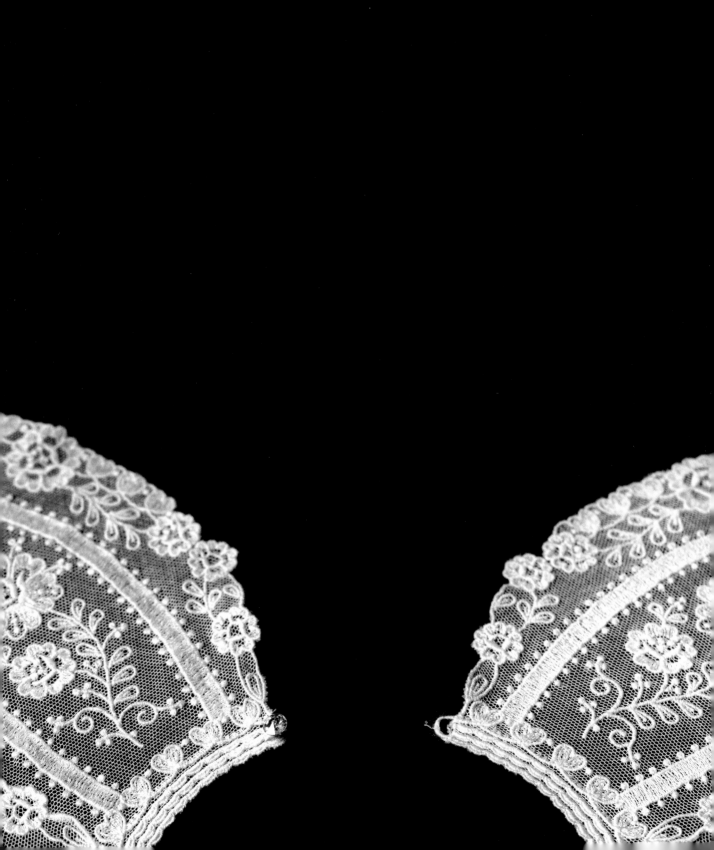

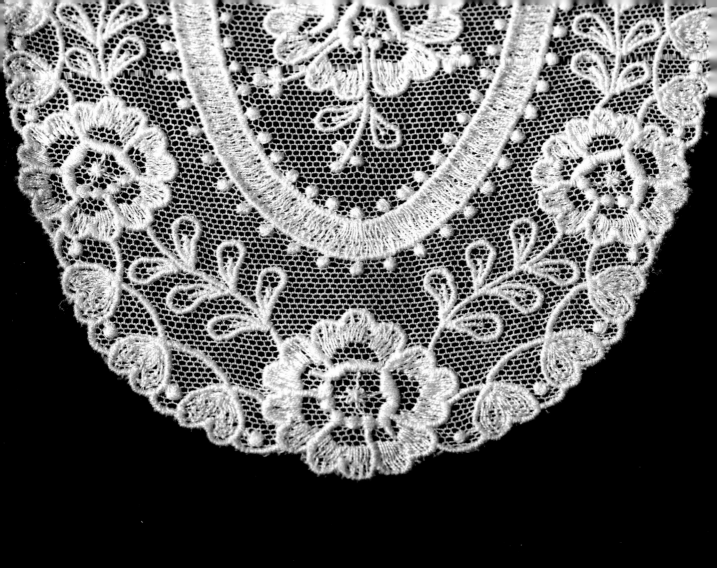

"The institution we serve is far more important than the particular individuals who compose the Court's bench at any given time. And our job, in my view, is the best work a jurist anywhere could have. Our charge is to pursue justice as best we can."

PEGASUS

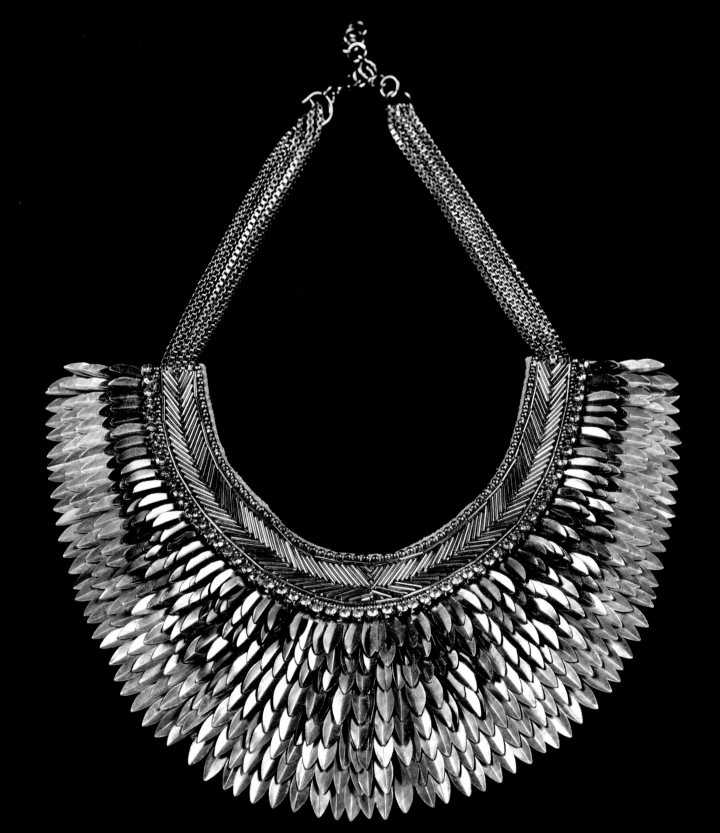

THIS LIMITED-EDITION "Pegasus Necklace," made in India for the accessories company Stella & Dot, is fashioned out of pointed gold feathers and hand sewn onto silk organza. It was given to the justice by a fan, Los Angeles–based lawyer Susan Hyman.

In 2018, as a tribute to Justice Ginsburg, Hyman wore the necklace to a screening of the documentary *RBG*. After seeing the film, she sent the piece to RBG as a token of appreciation. The collar reminded Hyman of "something a warrior princess like Wonder Woman would wear as armor into battle. It projects strength, confidence, and fearlessness." Hyman received a card of thanks in return: "For today's surprise package, a thousand thanks. The necklace is exquisite. I will enjoy wearing it on the bench and off as well."

RBG kept her promise: she wore the Pegasus collar on November 30, 2018, for the first Supreme Court group portrait following Brett Kavanaugh's appointment confirmation to the court. The portrait went viral on social media, along with speculation that her sartorial choice—and her expression in the photograph—was meant to telegraph her disapproval of her newly appointed colleague. Hyman was thrilled to see the necklace worn by Justice Ginsburg—she felt it was a signal of solidarity.

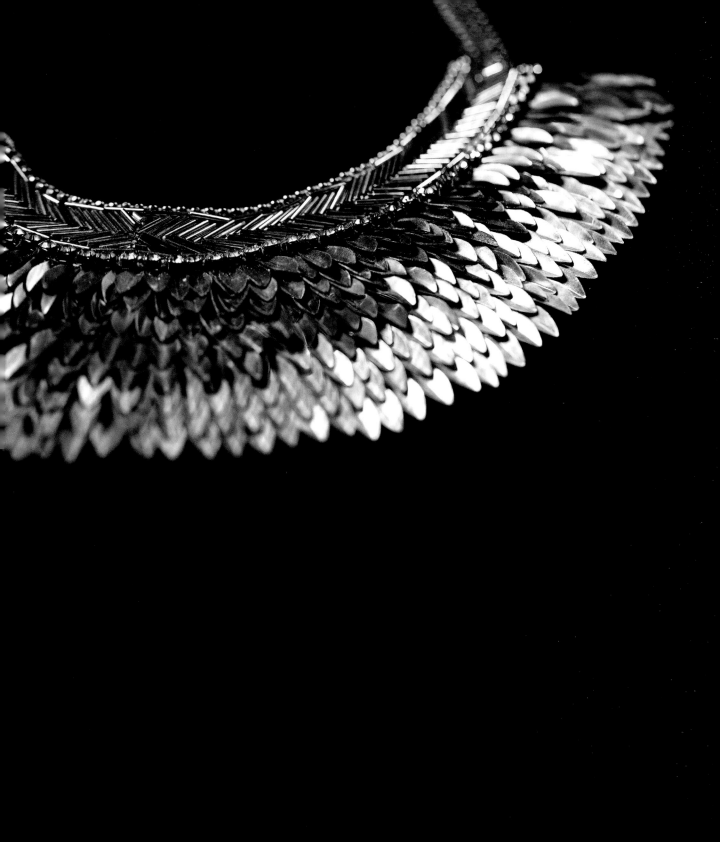

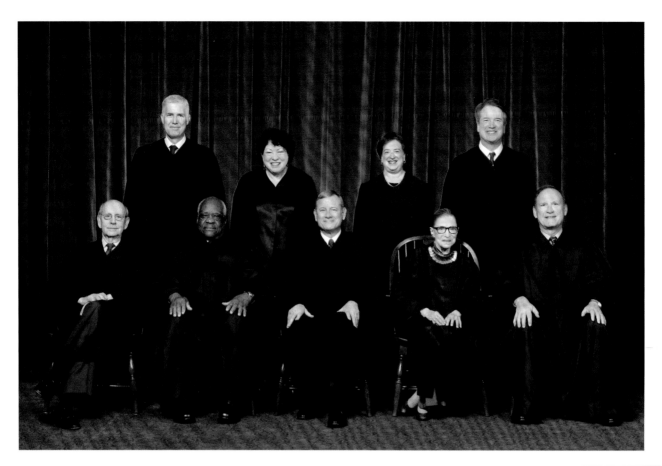

Supreme Court group portrait,
November 30, 2018—the first
portrait to include Justice Brett
Kavanaugh.

A close-up of RBG from the 2018
group portrait session.

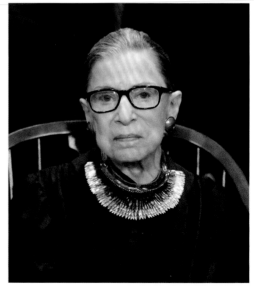

"When will there be enough women on the court? My answer, 'When there are nine.' And some people find that answer astonishing. . . . I remind them that for generations, only men composed the [Supreme] Court. Nobody thought there was anything wrong with that."

FAMILY

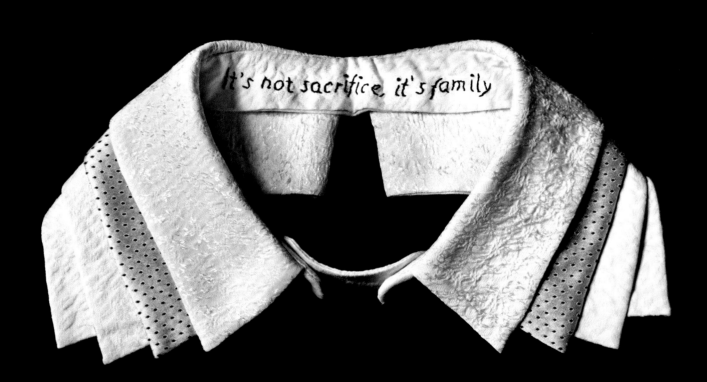

IN 2018, RBG's former and then-current law clerks commissioned the female-founded fashion company M.M.LaFleur to custom design a gift to celebrate her eighty-fifth birthday and twenty-fifth year on the Supreme Court. "This whole design process was a true collaboration between M.M.LaFleur's design team and Justice Ginsburg's team of clerks," explains Miyako Nakamura, the company's chief creative officer. "I realized quickly how passionate they were about making this piece into a symbol that truly represented her." The ever-present support of Justice Ginsburg's family made her work possible, and this collar represented those interconnected relationships. As Nakamura describes it, "We felt that the collar articulated how a strong familial bond can help a woman achieve greatness at work."

M.M.LaFleur is known for polished, tailored styles for women, and Nakamura took inspiration from those tailoring elements to create a design that emphasized construction rather than embellishment. Aesthetically and conceptually, the construction resembles a man's shirt collar with an element of femininity and added meaning. "For the design, I used three ivory-colored jacquards to symbolize the familial layers that underpinned Justice Ginsburg's life," recounts Nakamura. The first layer, made of textured jacquard, represents RBG; the layer underneath, made of polka-dotted jacquard and reminiscent of a man's tie, represents her husband, Marty; and the two additional layers, made of floral jacquard, represent their children, Jane and James. "Like magic, the top layer of the collar curved slightly into the bottom layer; it looked like family members being nestled together and supporting one another to be able to blossom."

To underscore this theme of family, Nakamura incorporated Marty's words into the design. In 1993, the year his wife joined the Supreme Court, Marty articulated the couple's mutual respect for each other: "I have been supportive of my wife since the beginning of time, and she has been supportive of me. It's not sacrifice; it's family." That last sentence was the line Marty would repeat when people wondered why he was giving up his successful law practice in New York City to move to DC for his wife's career. "People saw him as giving up all these benefits and whatever, and to him family was the benefit," explains James Ginsburg, their son. Marty's words are hand-embroidered in black thread on the inside of the collar. "He had enormous confidence in my ability," RBG said about her husband, "more than I had in myself."

Nervous, excited, and honored, Nakamura and the CEO of M.M.LaFleur, Sarah LaFleur, traveled to RBG's chambers in Washington, DC, twice, for fittings. LaFleur said, "It was the closest I ever came to meeting my personal god." For Nakamura, it was an experience that continues to ground and shape her. "To think: I might not have been here, working as a female designer and making a living from my passion, if she wasn't there to create a foundation for our modern society. . . . RBG was known to have loved opera and to have quite the admiration for the singers' gifted voices, and she once noted that *her* gift was in practicing law. I think that she taught all of us to work with the talents you are given to make a difference for the better. I think back on this experience when I question the meaning of what I am doing with my life's work, and she anchors me."

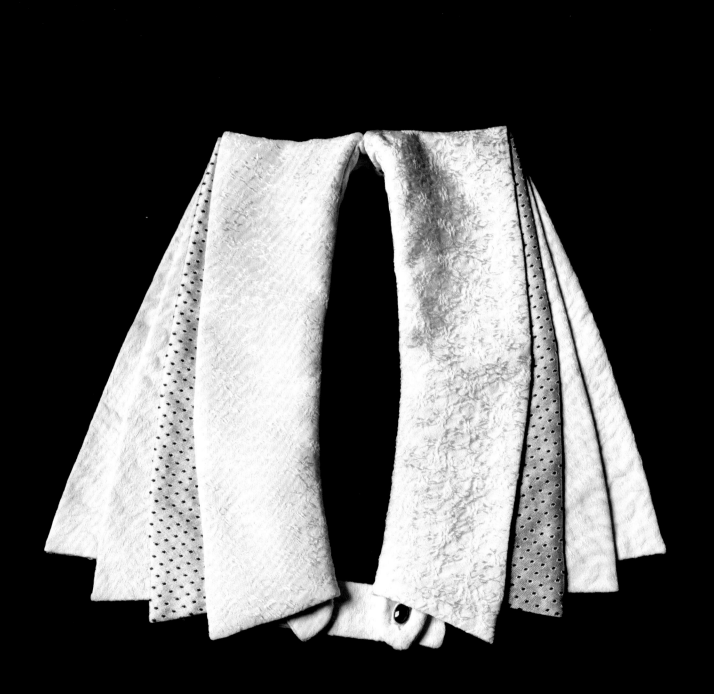

"The idea of feminism I hold high was put in this fitting way by a DC-area suffragist, Lydia Pearsall, whose life spanned more than a century: 'I never wanted to become a man,' she said, 'just his equal, and in the process, it seemed to me we would both become a little better.'"

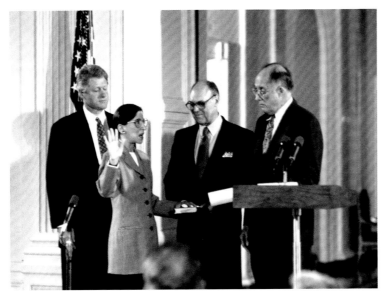

RGB raises her right hand while Justice William Rehnquist administers the oath of office. Her husband, Marty, holds the Bible as she is sworn in as an associate justice of the Supreme Court of the United States, August 10, 1993.

RBG and Marty with their daughter, Jane, 1958.

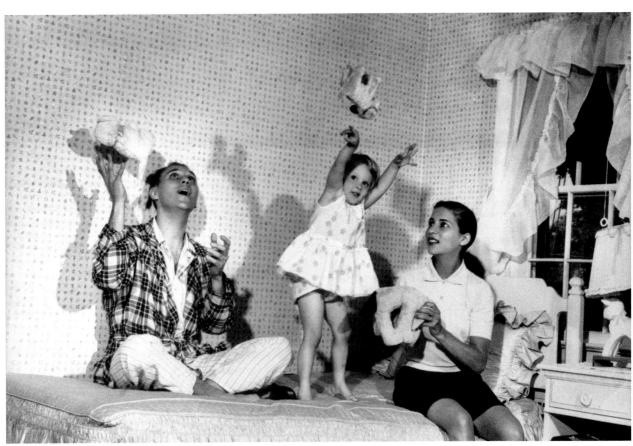

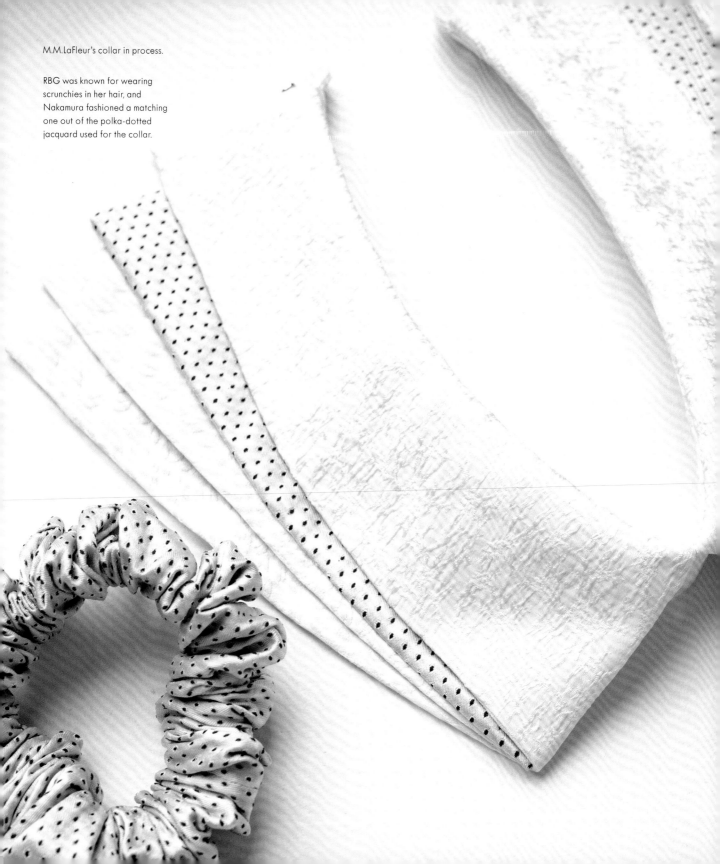

M.M.LaFleur's collar in process.

RBG was known for wearing
scrunchies in her hair, and
Nakamura fashioned a matching
one out of the polka-dotted
jacquard used for the collar.

When I was introduced at functions in town, the introducers would often say, 'This is Justice Ginsburg,' and the hand would go out to Marty. Women were still very rare on the federal bench. Marty would tell them, 'She's the judge.'"

STIFFELIO

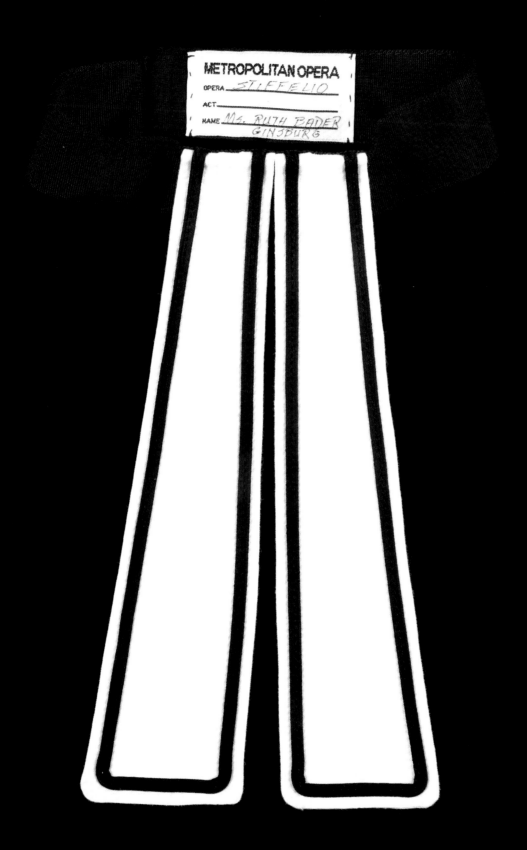

IN 2010, Plácido Domingo wore a jabot similar to this one in a production of Verdi's *Stiffelio* at the Metropolitan Opera House, in New York City. In the story, Stiffelio, a Protestant minister, wore this piece as part of his clerical robe. As a memento, the Met costume shop gifted RBG a replica of the original with her name and the title of the opera handwritten on the inside band.

Justice Ginsburg was first introduced to opera in 1944, at age eleven, when her aunt took her to a condensed version of *La Gioconda* conducted by Dean Dixon and performed at a high school in Brooklyn. "It was an overwhelming experience," she remembered years later. "High drama conveyed through glorious music—I was spellbound."

She was an avid opera fan throughout her life, a passion she shared with her husband, Marty, whose parents held season tickets to the Met. When they were students at Harvard Law, they attended performances in Boston, and when Marty was serving in the US Army and they relocated to Fort Sill, Oklahoma, they followed the Met on tour to Dallas. The Ginsburgs made sure to introduce their children to opera at an early age, too. They took their eight-year-old daughter, Jane, to see *Così fan tutte*. "In preparation, we played the recording again and again, and read the libretto together at least three times," Justice Ginsburg recalled. For their son, James, his first opera was *Aida*.

RBG also shared this passion with her dear friend and colleague on the bench Antonin Scalia, and they often attended performances together. In 2015, they watched the story of their bond unfold onstage when the composer Derrick Wang wrote an operatic comedy about their loyal friendship. "Toward the end of the opera *Scalia/Ginsburg*, tenor Scalia and soprano Ginsburg sing a duet: 'We are different, we are one,'" RBG

wrote in a remembrance for her friend after his death. "Different in our interpretation of written texts, one in our reverence for the Constitution and the institution we serve. From our years together at the DC Circuit, we were best buddies."

Opera was a sanctuary for Ginsburg, a break from her tireless work on the bench. "You need a respite from the briefs. There's no question about it; you can't have a steady diet of them," she explained in an interview. "So my respite is, for example, the Washington National Opera, whether it's a performance or a dress rehearsal. . . . All work and no play makes the judge a dull person."

Opera was not only an outlet of joy for RBG, but also a form of self-expression. As early as 1994, she and Justice Scalia—dressed in costume and wearing wigs—were supernumeraries (the opera equivalent of film extras) in the Washington Opera's production of *Ariadne auf Naxos*, and in 2003, she and fellow justices Kennedy and Breyer played themselves in nonspeaking roles in *Die Fledermaus*. The three justices stood just a few feet from Domingo onstage. "I had never heard a voice of that beauty so close up. It felt as if an electric shock were running through me," Ginsburg recalled. She was happily overwhelmed again in May 2011: the legendary Spanish opera singer surprised her with a serenade when the two received honorary degrees from Harvard University. In 2016, she had a small, comedic speaking role in the Gaetano Donizetti opera *La Fille du Régiment*. Ginsburg played a role typically reserved for an aging diva and brilliant improviser. She wrote her lines, in collaboration with a dramaturge, to fit the political climate.

On the evening of her passing, opera houses across the country dimmed their lights in her honor.

METROPOLITAN OPERA

OPERA _STIFFELIO_

ACT _____

NAME _Ms. RUTH BADER GINSBURG_

RBG embraced a small speaking role as the Duchess of Krakenthorp in Gaetano Donizetti's *La Fille du Régiment* at the Washington National Opera, November 12, 2016.

"Most of the time, even when I go to sleep,

I'm thinking about legal problems. But when

I go to the opera, I'm just lost in it. Loving it.

And I don't think about any legal brief."

"Truth be told, I am ill equipped to break

out in song. My grade school music

teacher ranked me a sparrow, not a

robin. The instruction given me, do not

sing, only mouth the words. Still, in my

dreams, I can be a great Diva, often

Renata Tebaldi, sometimes Beverly Sills

or Marilyn Horne."

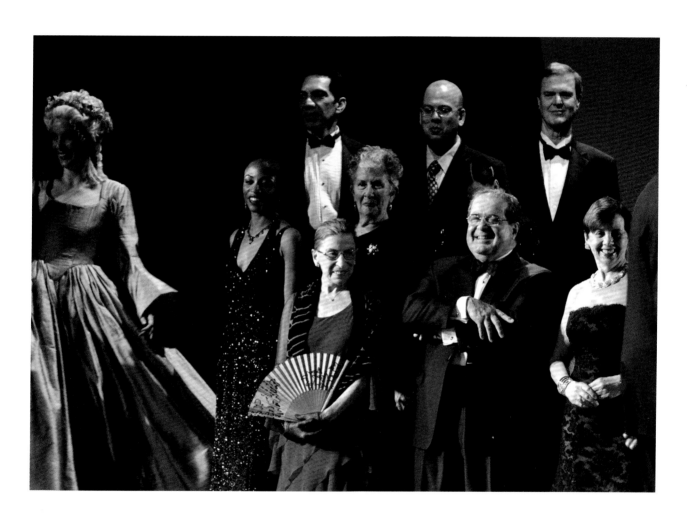

RBG and Justice Scalia were among
the supernumeraries in the opening
night performance of *Ariadne auf
Naxos* at the Washington National
Opera, October 24, 2009.

ADVOCACY

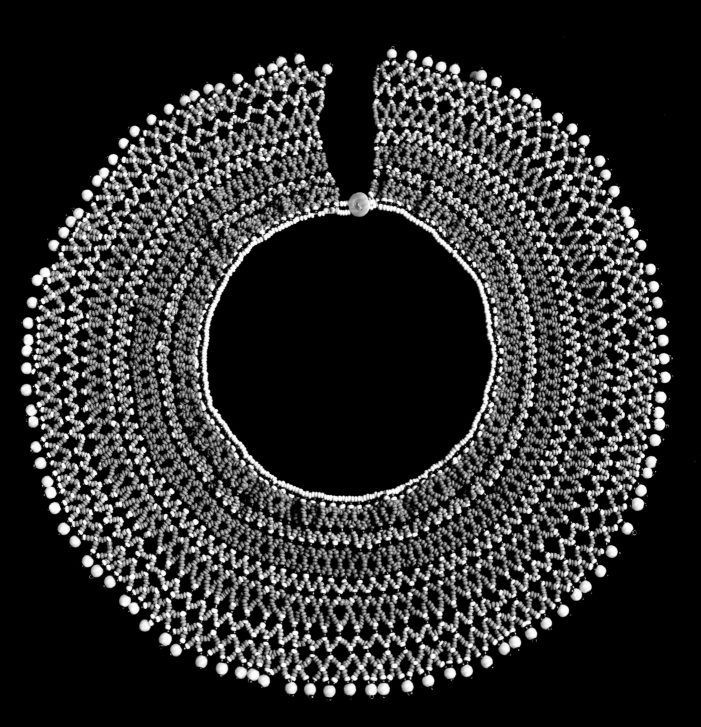

IN 2013, the Women's Law & Public Policy Fellowship Program and the Leadership and Advocacy for Women in Africa Fellowship Program at Georgetown University Law Center gifted this pink, blue, and cream beaded collar to the justice. She wore it for two of President Obama's State of the Union addresses—in 2014, when he told a partisan Congress that this would be a "year of action" and that he would proceed "with or without" them, and in 2015, when he addressed both Republican-controlled houses of Congress for the first time.

The justice also wore it to officiate the wedding of David Hagedorn and Michael Widomski, on September 22, 2013, her second same-sex marriage ceremony. Hagedorn, a DC-based food critic, wrote a letter to Justice Ginsburg, asking her if she would officiate his and Widomski's wedding. She could indeed officiate, she let them know, so long as she finished by five thirty—she was going to the opera that evening.

Original gift case with the words "Thank you Justice Ginsburg!" engraved within.

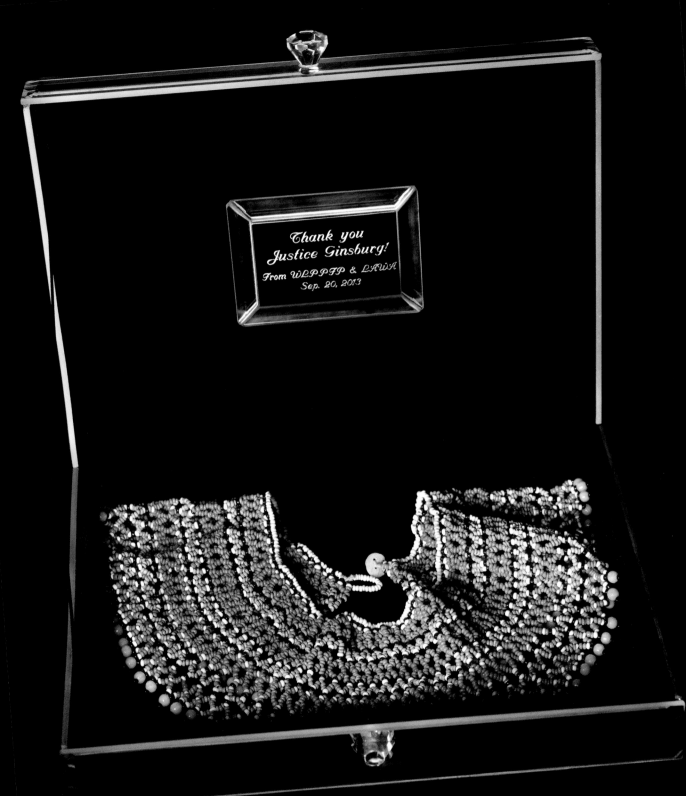

Thank you
Justice Ginsburg!
From WLPPFP & LAWA
Sep. 20, 2013

RBG officiates the wedding of Michael Widomski, *left*, and David Hagedorn, September 22, 2013.

OPPOSITE: RBG enters the House Chamber (followed by Justices Breyer and Sotomayor) for President Obama's State of the Union address, January 20, 2015.

"My number one advice is choose a partner in life who thinks that your work is as important as his."

PRIDE

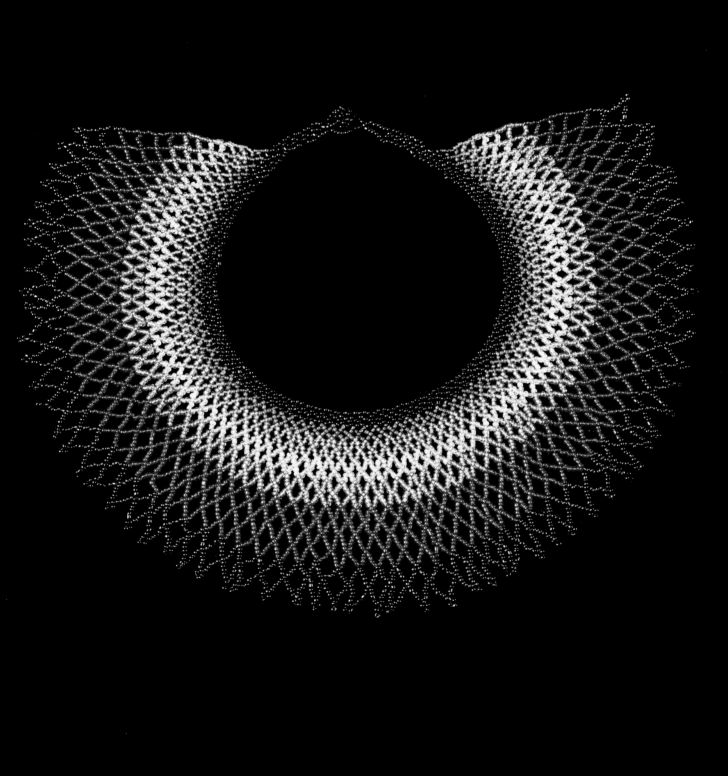

JILL MORRISON, executive director of the Women's Law & Public Policy Fellowship Program and the Leadership and Advocacy for Women in Africa Program at Georgetown University Law Center, gifted this netted, beaded collar to Justice Ginsburg. "I was traveling in Ecuador and spotted it and thought it would be perfect for her," remembers Morrison. "I was especially taken by the rainbow colors, of course, given the court's marriage equality opinion."

Morrison was referencing the June 26, 2015, Supreme Court ruling in *Obergefell v. Hodges*. The 5–4 vote asserted that the Fourteenth Amendment requires all states to grant same-sex marriages and recognize same-sex marriages granted in other states. "The nature of injustice is that we may not always see it in our own times," wrote Justice Kennedy in that case's majority opinion, which was joined by Justices Ginsburg, Breyer, Sotomayor, and Kagan. "The generations that wrote and ratified the Bill of Rights and the Fourteenth Amendment did not presume to know the extent of freedom in all of its dimensions, and so they entrusted to future generations a charter protecting the right of all persons to enjoy liberty as we learn its meaning. When new insight reveals discord between the Constitution's central protections and a received legal stricture, a claim to liberty must be addressed."

On October 5, 2016, when RBG wore this rainbow-beaded collar on the bench during oral arguments, journalists speculated whether she was signaling her support of LGBTQ+ rights. RBG was the first US justice to marry a same-sex couple and would go on to officiate many more such weddings, pronouncing them married by the powers vested in her by the Constitution of the United States. Her first—the wedding of Michael M. Kaiser, then-president of the Kennedy Center, and economist John Roberts—was in late August 2013, just a few months after she joined the Supreme Court majority decision in *United States v. Windsor*, a case establishing that the federal government has the power to recognize gay marriages and cannot discriminate against same-sex spouses for the purposes of determining federal benefits and protections. "I think it will be one more statement that people who love each other and want to live together should be able to enjoy the blessings and the strife in the marriage relationship," RBG said at the time.

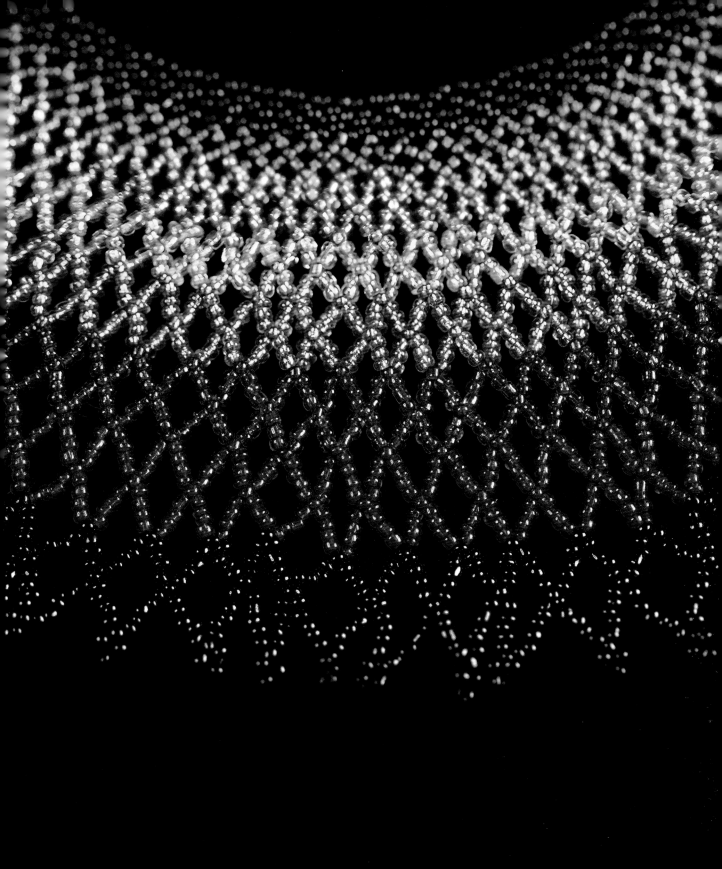

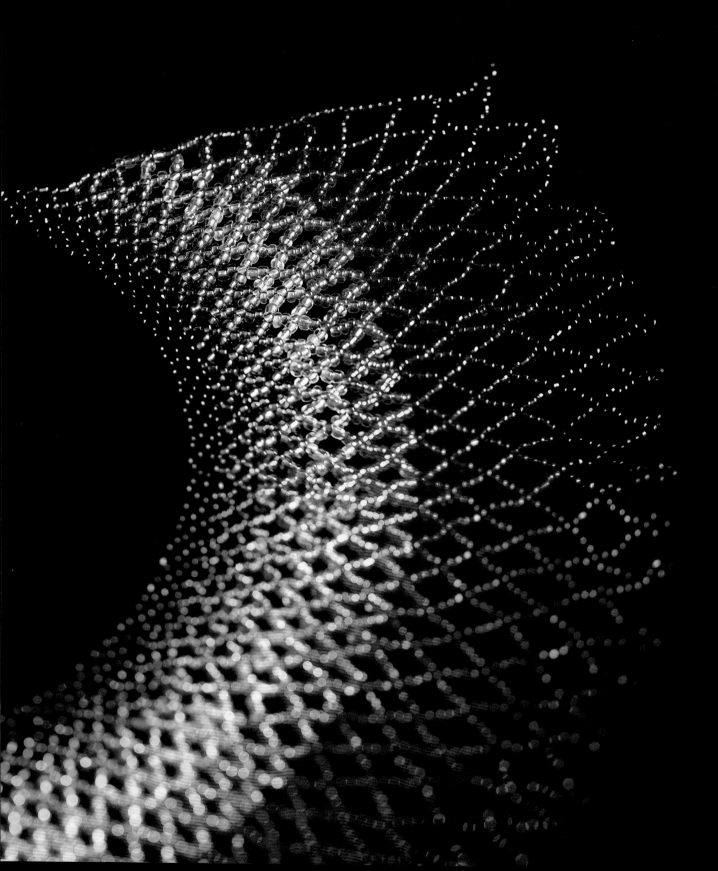

"I grew up in the shadow of World War II.
And we came to know more and more what
was happening to the Jews in Europe. The
sense of being an outsider—of being one of
the people who had suffered oppression for
no . . . no sensible reason . . . it's the sense of
being part of a minority. It makes you more
empathetic to other people who are not
insiders, who are outsiders."

"In recent years, people have said,
'This is the way I am.' Others looked
around, and we discovered it's our
next-door neighbor—we're very fond
of them. Or it's our child's best friend,
or even our child. I think that as more
and more people came out and said
that 'this is who I am,' then the rest of
us recognize that they are one of us."

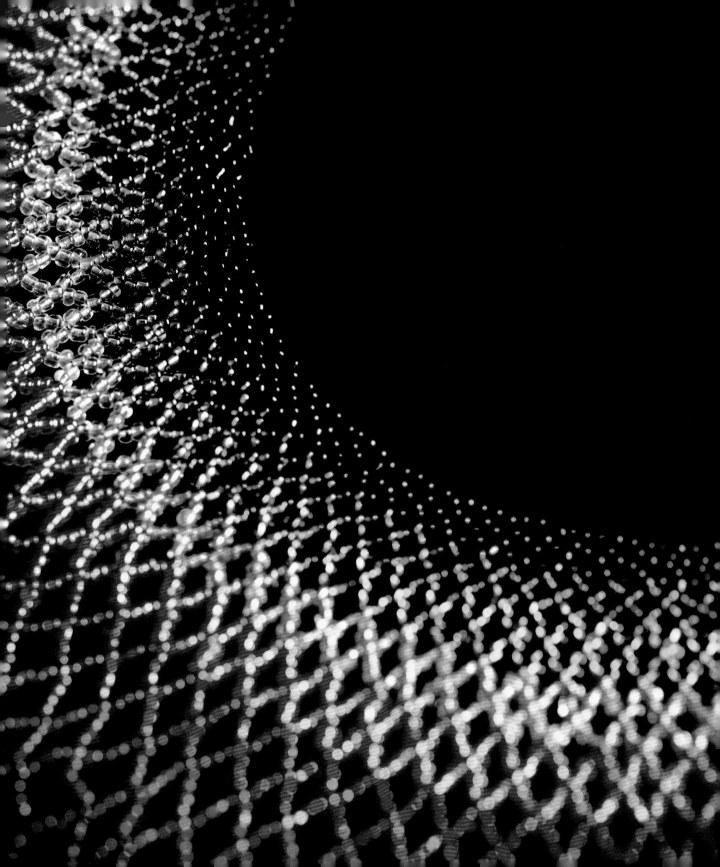

WEDDINGS

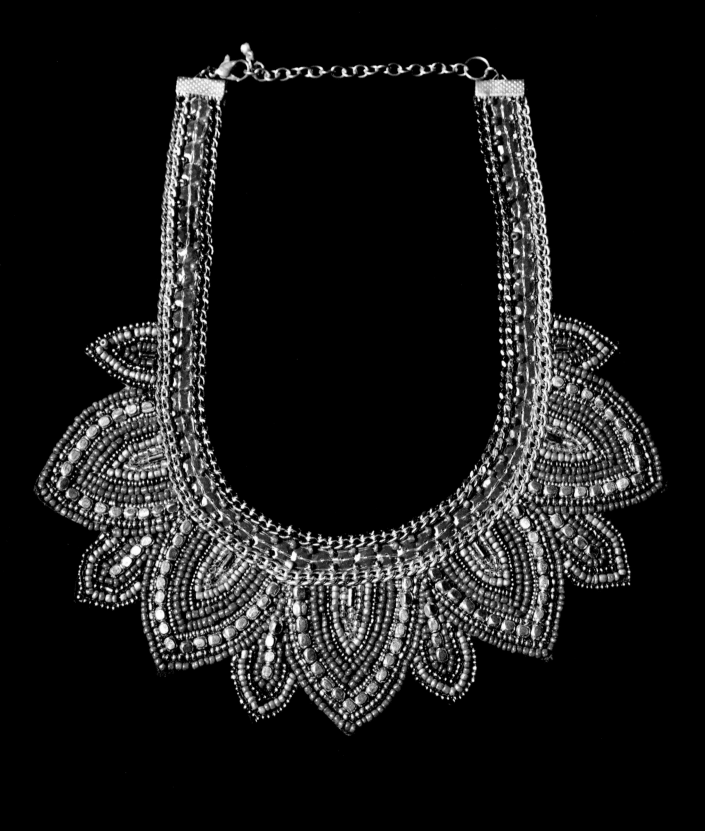

A COLLEAGUE GAVE JUSTICE GINSBURG this collar as a token of appreciation for officiating their wedding in 2017. That RBG found the time to officiate so many wedding ceremonies over the years is an example of how masterfully she harnessed her busy schedule, generously devoting time off the bench to attend these and other meaningful occasions of family, friends, colleagues, and former students and clients.

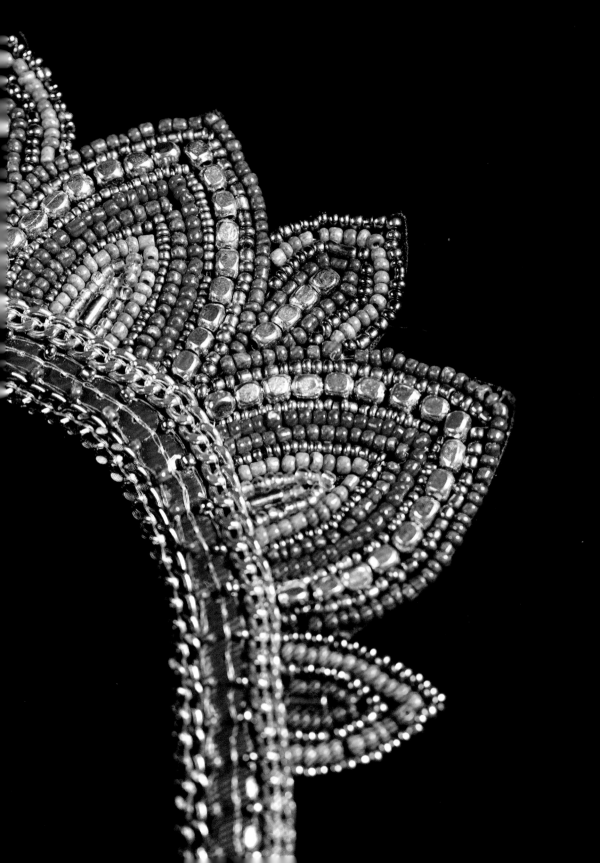

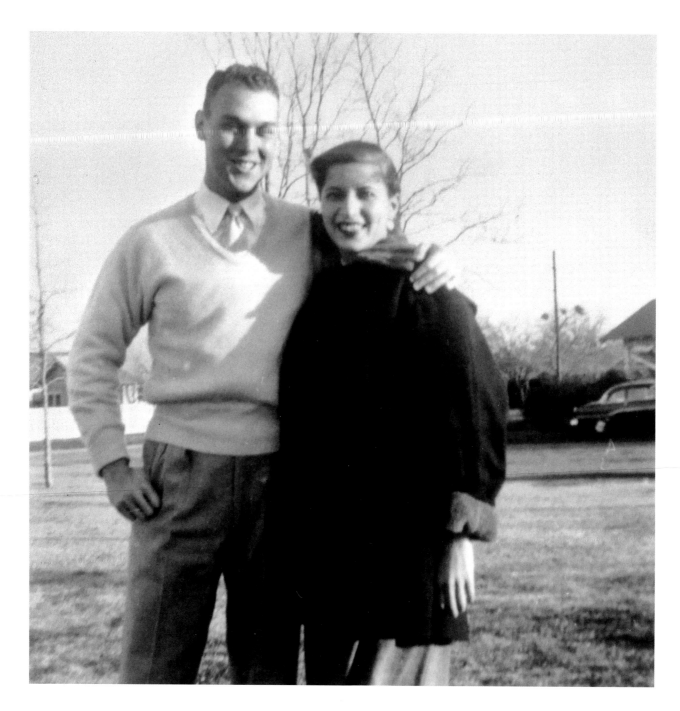

Ruth and Marty, Fort Sill, Oklahoma, when
the young couple was stationed there for
his army service, 1954.

"I have had more than a little bit of luck in life, but nothing equals in magnitude my marriage to Martin D. Ginsburg. I do not have words adequate to describe my supersmart, exuberant, ever-loving spouse. Early on in our marriage, it became clear to him that cooking was not my strong suit. To the eternal appreciation of our food-loving children . . . Marty made the kitchen his domain and became chef supreme in our home."

"Marty was the first boy I
ever dated who cared that
I had a brain, and we
started out as best friends."

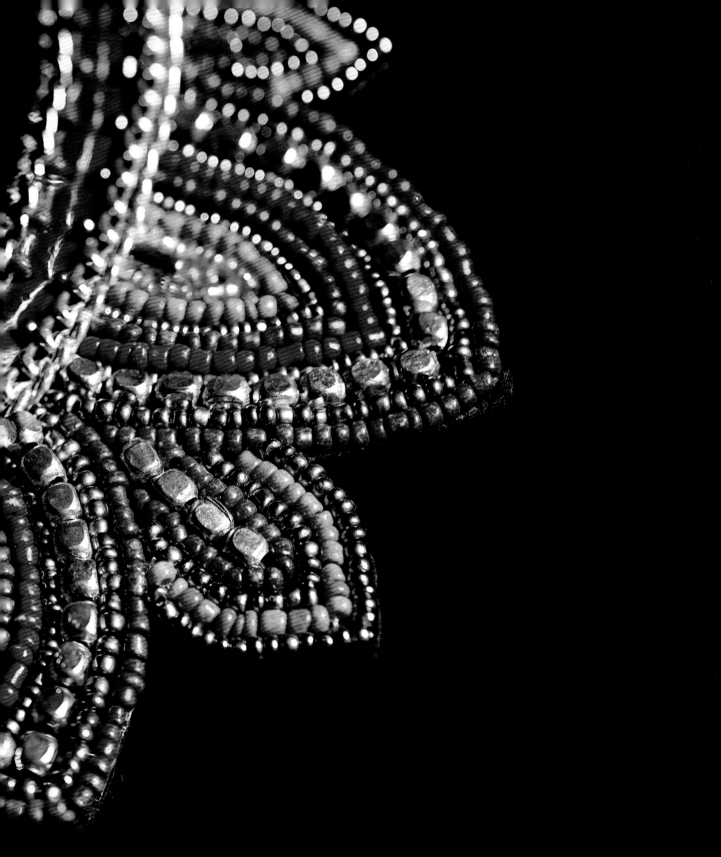

SUPREME

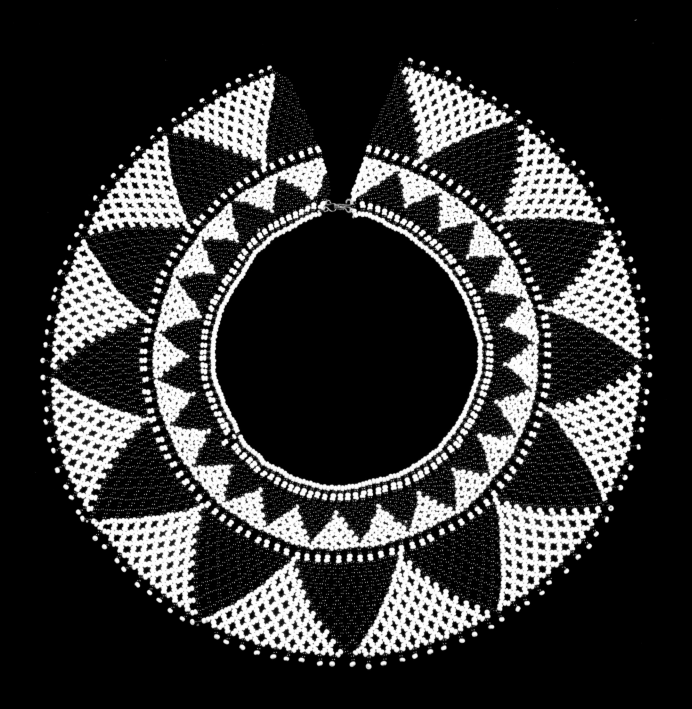

JUSTICE GINSBURG wore this black-and-white beaded necklace from South America to officiate a wedding on August 30, 2020, for Barb Solish and Danny Kazin. Solish posted a photograph from the ceremony on Twitter—in the image, the couple at the altar face the justice, who is wearing her black robe and this neckpiece—with the caption, "2020 has been rough, but yesterday was Supreme." It was the first time RBG appeared in public since she shared the news of her cancer recurrence the previous month. Less than three weeks later, on September 18, 2020, the world learned that she had died.

That Solish's tweet went viral was not surprising: it had been seven years since Justice Ginsburg had become a cultural symbol with superstar status. It started in 2013, after the Supreme Court decimated the Voting Rights Act in *Shelby County v. Holder* and RBG delivered her searing dissent (see page 48). Outraged by the Supreme Court's decision, Shana Knizhnik, an NYU student at the time, launched a blog in Ginsburg's honor, referring to the justice as "Notorious R.B.G.," a play on the name of the legendary rapper the Notorious B.I.G. The name stuck. Overnight, it seemed, RBG became an icon: her face and slogans ("You Can't Spell Truth Without Ruth") were silkscreened and printed on T-shirts, mugs, Halloween costumes, and baby bibs—every surface lent itself to an RBG product. "Why is the younger generation interested in an octogenarian like me?" she asked in a 2017 interview. "Well, one thing the *Shelby County* dissent illustrated is that one can disagree without being disagreeable and one can be effective by avoiding invectives and, instead, employing rea-soned responses. So, that's how the *Notorious RBG* began."

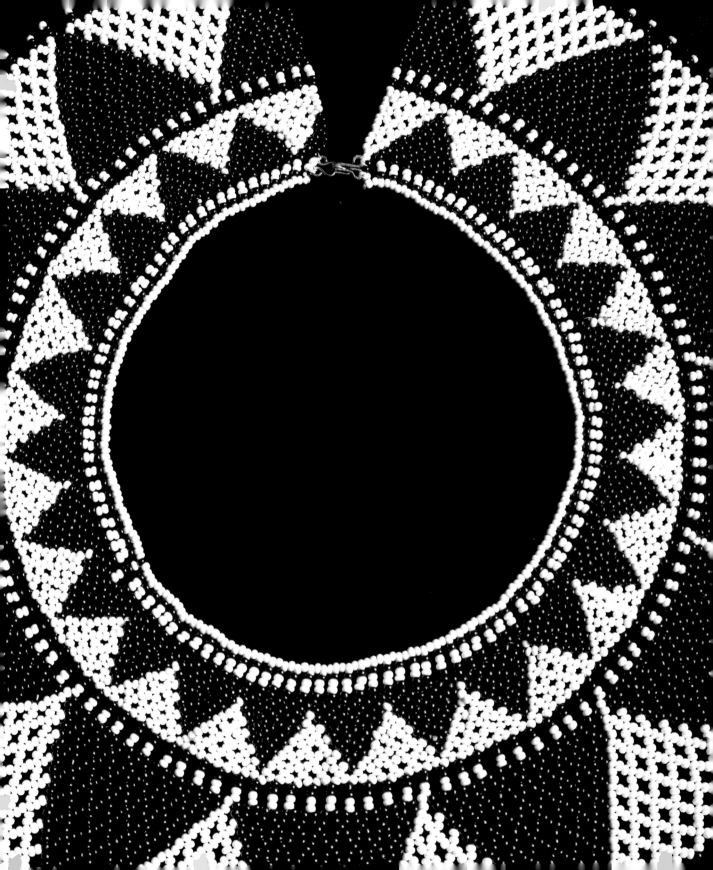

"I will confess that Marty and I have survived nearly forty-three years in each other's constant company because of advice given to me by his mother on our wedding day. This was her prescription for a happy, enduring marriage: 'It pays,' she said, 'it pays sometimes to be a little deaf.'"

FAVORITE

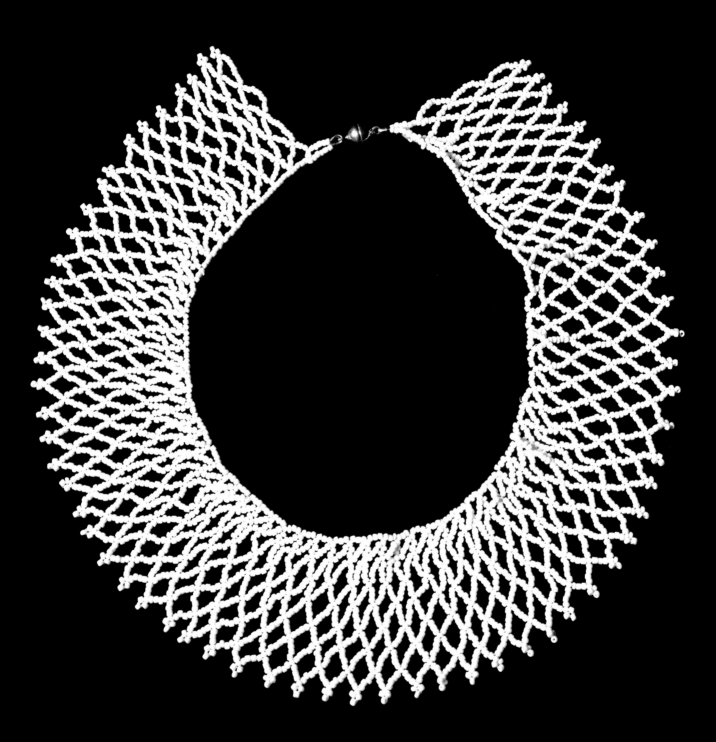

THIS WHITE BEADED COLLAR from Cape Town, South Africa, was Justice Ruth Bader Ginsburg's favorite. Among a variety of milestone moments, she wore it to President Obama's address to the joint session of Congress in 2009; for his State of the Union, in 2010, when he described the country's "deficit of trust" in the government and the imperative of fixing it; in 2011, after the Democrats had lost control of the House a few months earlier; in 2012, as Obama geared up for the fall election; and for Pope Francis's address to the joint session of Congress in 2015—the first time a pope addressed Congress.

It was also the collar she chose to wear for various court group photographs, for her own portrait that hangs in the Supreme Court, for her 2015 portrait as one of *Time* magazine's 100 most influential people, and for Nelson Shanks's 2012 portrait *The Four Justices*. Shanks's epic, large-scale oil painting depicts the four female justices who had served on the US Supreme Court since 1981—Sandra Day O'Connor, Ruth Bader Ginsburg, Sonia Sotomayor, and Elena Kagan. "After Sandra left, I felt very lonely," Justice Ginsburg remembered, "and it was the wrong image for the schoolchildren, particularly, to come in and see this bench with eight men and one very small woman. Now, I sit toward the center by virtue of seniority and Justice Kagan is on my left, and Justice Sotomayor is at my right. We look like we are all over the bench. We are here to stay."

It is fitting that her favorite collar is from South Africa: she had great reverence for the constitution of the Republic of South Africa, ratified in 1996, which she described as "a deliberate attempt to have a fundamental instrument of government that embraced basic human rights" with an "independent judiciary."

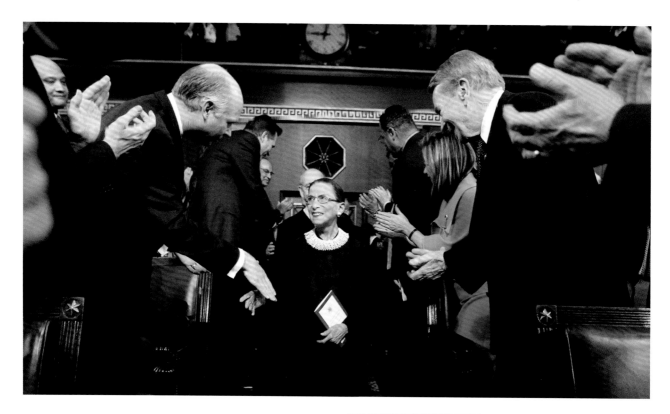

RBG arrives for President Obama's address to a joint session of Congress, February 24, 2009.

President Obama greets RBG at his State of the Union address, January 24, 2012.

OPPOSITE: RBG is photographed in the East Conference Room at the US Supreme Court to celebrate her twentieth anniversary on the bench, August 2013.

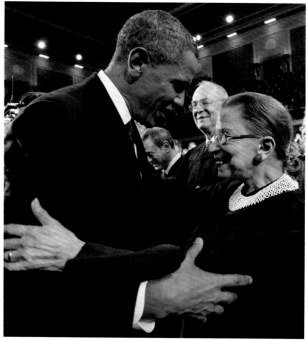

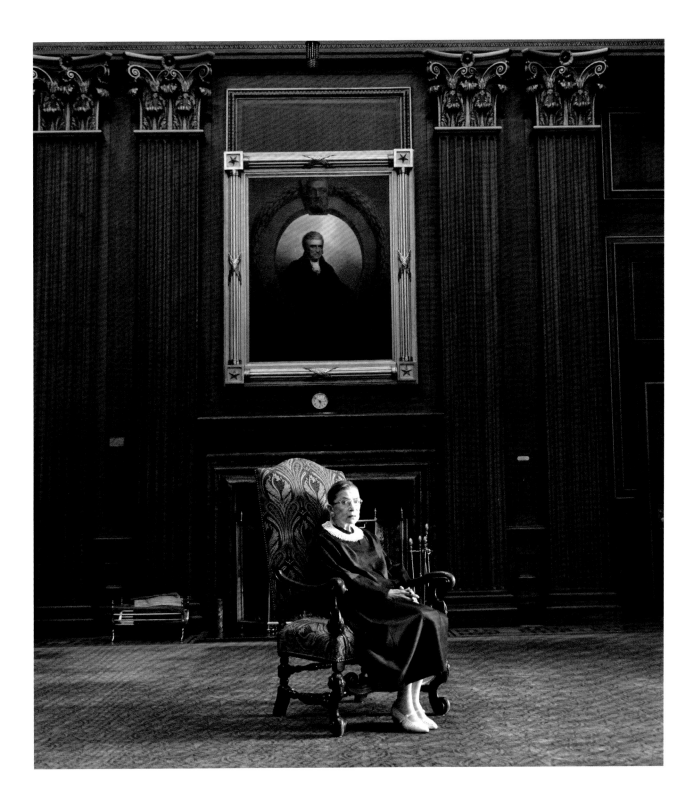

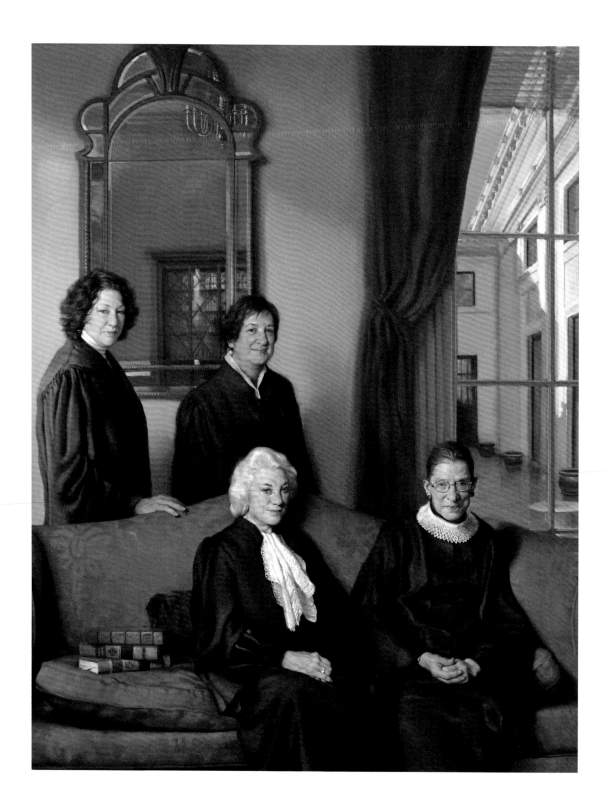

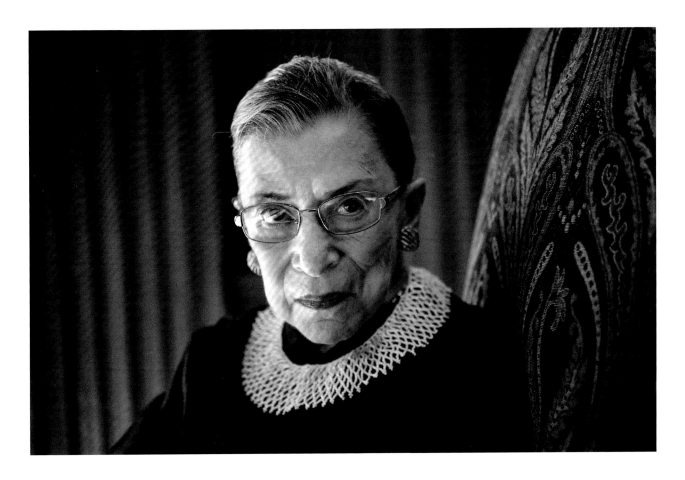

One of a series of portraits taken
to mark RBG's twentieth
anniversary on the Supreme Court
bench, August 2013.

OPPOSITE: Nelson Shanks's 2012
oil painting *The Four Justices*, which
measures approximately seven
feet by five and a half feet. In spite
of the logistical scheduling
challenges, the artist created the
painting from life: all four justices
sat for Shanks in his studio.

GILT GLASS

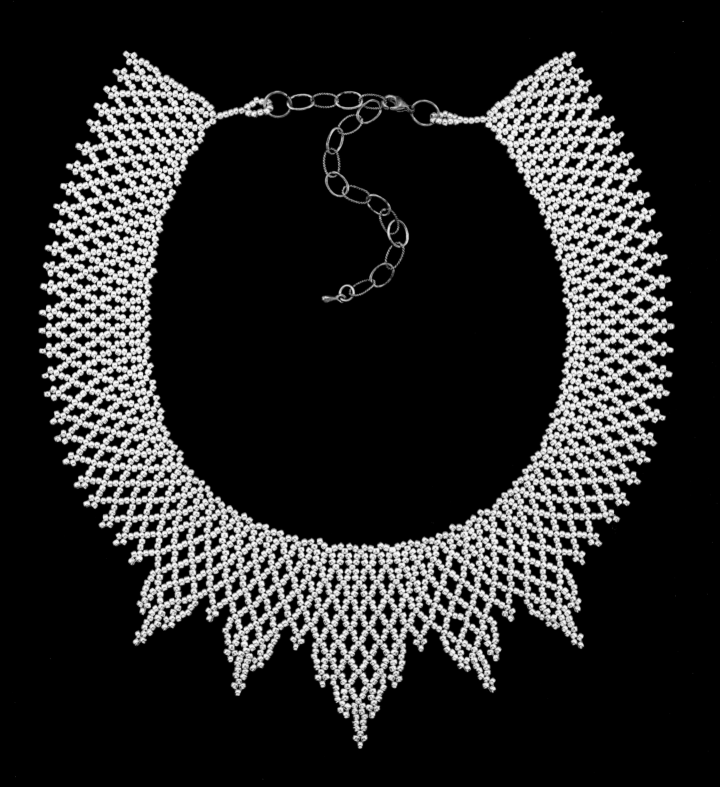

LITTLE IS KNOWN ABOUT THE ORIGINS of this beaded piece in Justice Ginsburg's collection, but in September 2022, days before the second anniversary of her death, it was one of roughly seventy-five personal objects auctioned off by Bonhams. This judicial collar—the first available for purchase—sold for $176,775, nearly sixty times its estimated value. Other personal objects that were part of the auction included a wooden gavel ($20,400), a pair of black lace gloves ($16,575), a pair of opera glasses ($10,837.50), and salt and pepper shakers ($4,845). The auction raised more than half a million dollars, all of which established the RBG Endowment Fund, a charitable trust that supports the initiatives of SOS Children's Villages, the world's largest nonprofit and social development organization dedicated to the care of vulnerable children and families at risk of separation.

Also after her death, RBG's children, Jane and James, generously donated a number of their mother's artifacts to the Smithsonian's National Museum of American History, including four collars (Lace, page 26; Majority, page 36; Dissent, page 46; and Sunrise, page 156); her judicial robe, briefcase, and nameplate; blank letterhead and notecards from her chambers; a bobblehead doll; twelve briefs for cases she argued; and a framed copy of the Lilly Ledbetter Fair Pay Act of 2009. These treasures, among other possessions donated by the Ginsburg family, live alongside the robe that Sandra Day O'Connor donated to the Smithsonian, the one she wore to her swearing-in ceremony on September 25, 1981.

"If you want to be a true professional, you will do something outside yourself. . . . Something to make life a little better for people less fortunate than you. That's what I think a meaningful life is—living not for oneself, but for one's community."

ANU

MONTHS BEFORE HER DEATH, RBG received a letter from Ambassador Alfred H. Moses, the chair of the board of governors of ANU—the Museum of the Jewish People in Tel Aviv (*anu* means "we" in Hebrew): Would the justice be open to donating an artifact to the museum? She sent a personal reply a few weeks later: "I would be glad to contribute to the Museum of the Jewish People in Tel Aviv one of the collars I wear with my robe at oral arguments," she wrote. "Would that be satisfactory?"

RBG donated this hand-crocheted collar with a thick gold edge and pearl clasp, along with a signed copy of her autobiography, *My Own Words*. Shulamith Bahat, the chief representative of ANU in North America, visited the justice in her chambers at the Supreme Court on March 4, 2020, to retrieve the collar in person. It was just one week before the World Health Organization declared the highly transmissible coronavirus a global pandemic—right before borders started to close, travel came to a halt, schools canceled in-person classes, and the world locked down. "She was the first person I saw in Washington, DC, at the time, wearing a mask," Bahat remembered. The justice was on her way to hear the court's first major abortion-related case since President Trump took office.

ANU, the largest Jewish museum in the world, is dedicated to telling the story of the Jewish people and committed to preserving Jewish identity and culture from antiquity to present day. RBG's crocheted collar and signed autobiography are displayed alongside artifacts belonging to other Jewish luminaries, including a guitar played by Leonard Cohen at a concert in Israel, the typewriter used by Yiddish writer Isaac Bashevis Singer, a pair of jeans manufactured by Levi Strauss in 1935, sheet music belonging to Irving Berlin, a baseball bat swung by Sandy Koufax, and one of the iconic wrap dresses designed by Diane von Furstenberg. Nearby media and interactive stations share the biographies of 150 Jewish cultural figures—philosophers, artists, filmmakers, musicians, writers, and more—including Gertrude Stein, Marc Chagall, Barbra Streisand, Franz Kafka, Bob Dylan, Sigmund Freud, Anne Frank, and the Coen brothers.

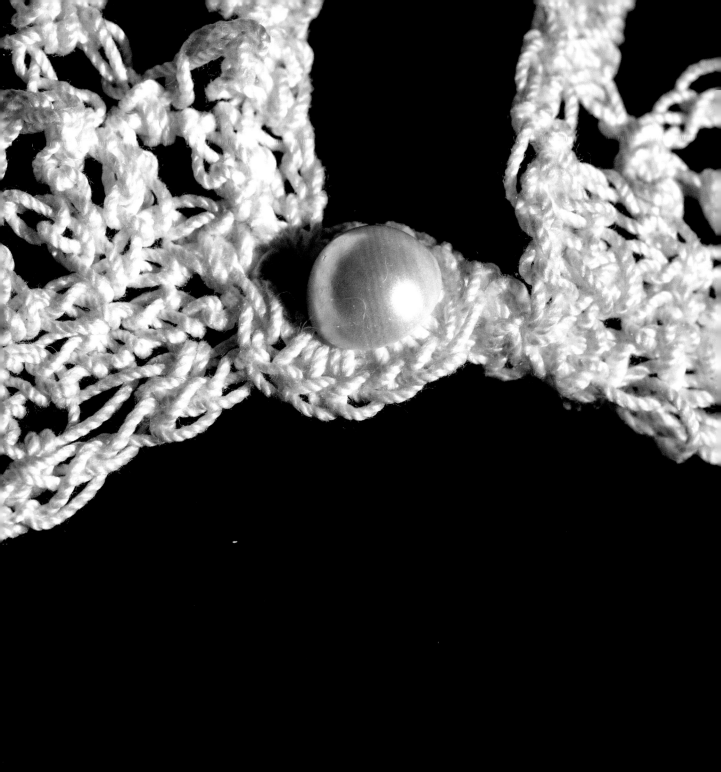

My heritage as a Jew and my occupation as a judge fit together symmetrically. The demand for justice runs through the entirety of Jewish history and Jewish tradition. I take pride in and draw strength from my heritage, as signs in my chambers attest: a large silver mezuzah on my door post, [a] gift from the Shulamith School for Girls in Brooklyn; on three walls, in artists' renditions of Hebrew letters, the command from Deuteronomy: '*Zedek, zedek, tirdof*'—'Justice, justice shall you pursue.' Those words are ever-present reminders of what judges must do that they 'may thrive.'"

PLEATED

JUSTICE GINSBURG generously donated select collars and jabots to museums around the world, including this one, which resembles a necktie and evokes the traditional jabots she wore earlier in her tenure on the Supreme Court. It is now part of the artifact collection of the Weitzman National Museum of American Jewish History in Philadelphia.

Bill Clinton with Supreme Court justices, circa 1993. *From left to right:* Justices Scalia, Ginsburg, Kennedy, Stevens, Rehnquist, Blackmun, O'Connor, Souter, and Thomas.

RBG's jabot, on display at the Weitzman National Museum of American Jewish History, Philadelphia.

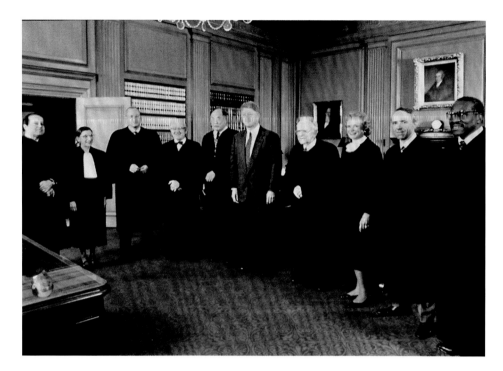

"My room has the only mezuzah in the US Supreme Court. . . . Growing up Jewish, the concept of *tikkun olam*, repairing tears in the community and making things better for people less fortunate, was part of my heritage. The Jews are the people of the book and learning is prized above all else. I am lucky to have that heritage."

SUNRISE

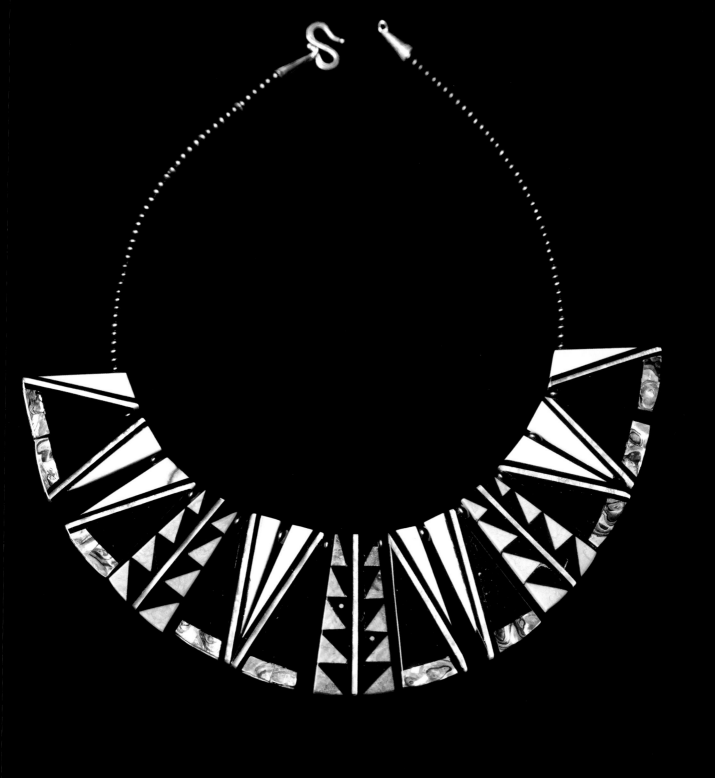

JUSTICE GINSBURG formed a special relationship with New Mexico. She visited the state often for work and for pleasure—to speak at symposiums, officiate weddings, meet with schoolchildren, enjoy the open-air performances of the Santa Fe Opera. In August 2016, she met with the New Mexico chapter of the International Women's Forum at the New Mexico Supreme Court. As a thank-you gift, the forum commissioned Gerard and Mary Calabaza, celebrated local artists from Santo Domingo Pueblo, to create this handcrafted collar for the justice.

For their geometric mosaic, the artists chose colors to reflect the palette of New Mexico, using stones and shells that hold special significance. Black jet from Pennsylvania for strength; light yellow archean butterstone from South Africa, healing; red apple coral from the South China Sea, protection; and the blue turquoise from Arizona, success. For the shells: the white mother-of-pearl from Indonesia represents love and peace; the abalone shell from New Zealand, peace and water. The centerpiece is designed with coral and includes two copper dots, the Calabazas' trademark. Strung alongside small black jet beads near the collar's sterling silver clasp is a quarter-inch copper disc stamped with the initials "GC"—also part of the Calabazas' registered trademark. Because RBG hailed from the East Coast, they titled the work *Sunrise*.

RBG wore this bright geometric piece for the Supreme Court group portrait in 2017. She also chose to wear the *Sunrise* collar at a 2018 US Citizenship and Immigration Services naturalization ceremony at the New-York Historical Society, the oldest museum in New York City. After reading about the Citizenship Project, a program at the NYHS that helps green card holders prepare for the US citizenship naturalization test, RBG wanted to get involved. "I thought it was a grand idea. So, I wrote to NYHS and said if ever I am in town when they had a naturalization ceremony, I would be glad to participate." Wearing her black Supreme Court robe and this collar, a symbol of the diversity of this country and those gathered before her, she administered the oath of allegiance to 201 new citizens from 59 countries. "My fellow Americans, it is my great privilege to welcome you to citizenship in the democracy that is the USA," she told the group. "Today, you join more than 20 million current citizens, born in other lands, who chose, as you have, to make the United States of America their home."

"We are a nation made strong by people like you who traveled long distances, overcame great obstacles, and made tremendous sacrifices—all to provide a better life for themselves and their families. My own father arrived in this land at age thirteen, with no fortune and speaking no English. My mother was born four months after her parents, with several children in tow, came by ship to Ellis Island. My father and grandparents reached, as you do, for the American dream. As testament to our nation's promise, the daughter and granddaughter of immigrants sits on the highest Court in the land and will proudly administer the oath of citizenship to you."

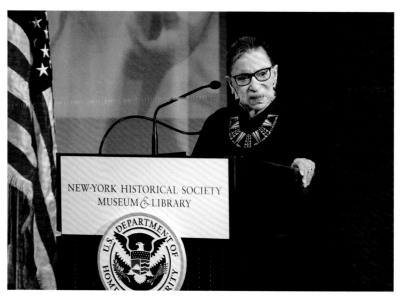

RBG administers the oath of allegiance to new US citizens at the New-York Historical Society, New York City, April 10, 2018.

Artists Gerard and Mary
Calabaza, 2016.

Supreme Court group portrait,
2017.

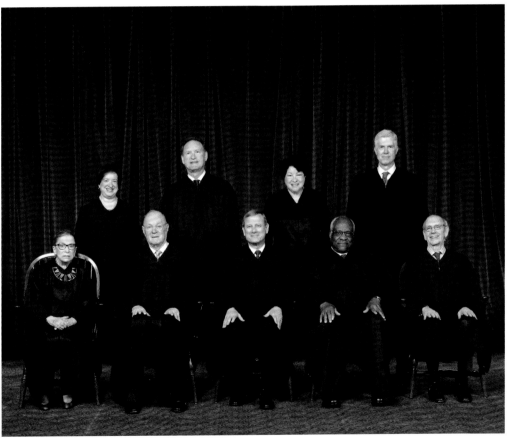

TWENTY-FIFTH
ANNIVERSARY

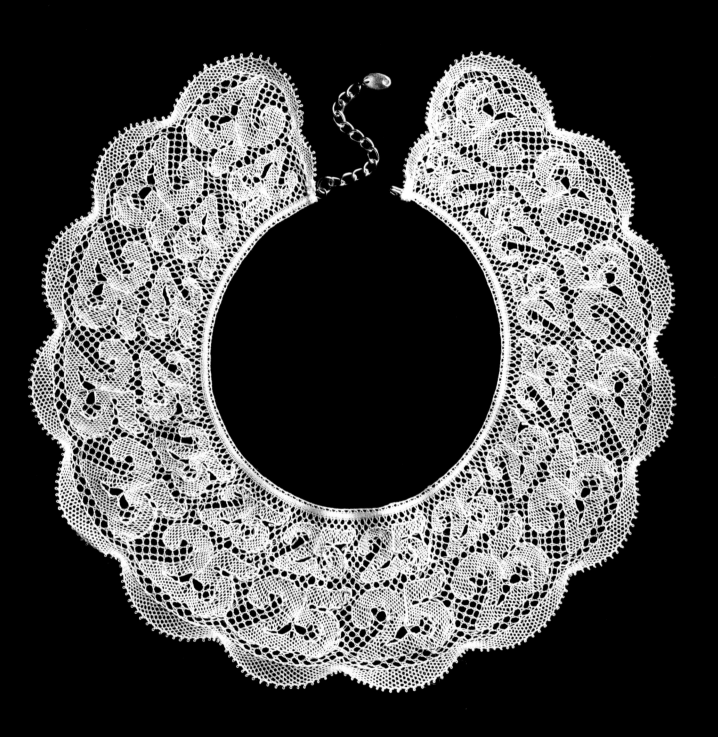

TO CELEBRATE JUSTICE GINSBURG'S twenty-fifth anniversary of her investiture to the US Supreme Court, Columbia Law School—where Ginsburg graduated at the top of her class, in 1959, tied for first place, and became its first tenured female professor in 1972—planned a panel discussion and private dinner for her. Columbia Law School's creative director, Kara Van Woerden, designed a graphic of a lace collar with spirals of interlocking 25s for the invitations and the cover of an accompanying volume marking the occasion, a collection of RBG's writings and correspondence with and about the school over nearly sixty years. Van Woerden commissioned the textile designer and founder of Brooklyn Lace Guild, Elena Kanagy-Loux, to bring the graphic to life in the form of a scalloped-lace collar.

By the time Columbia reached out to Kanagy-Loux in the summer of 2018, she had been practicing the art of lacemaking for six years and thinking about it for much longer. She grew up between Japan and the United States—influenced by both Tokyo's DIY fashion scene and rural Pennsylvania's Mennonite craft—and from an early age, she was embroidering, sewing, and making her own clothes. When she couldn't find a lacemaking teacher locally, she googled "lace school" and discovered a class in Slovenia (taught at the only lace school she could find online at the time). She packed her bags and showed up unannounced at the Idrija Lace School, founded in 1876. She learned to appreciate the freedom of lace, which she describes as a textile where the pattern is defined by the spaces *between* the threads.

The collar that Columbia Law School commissioned Kanagy-Loux to make was her most ambitious. She decided to use Egyptian cotton and a heavy Japanese silk for the gimp (the thread used to outline the pattern), which gives lace a smooth and lustrous finish. The collar took approximately three hundred hours to make. It was painstaking—her back ached, her eyes were bleary—and it called to mind the diligent handwork from centuries past, connecting her to lacemakers over the centuries, who, much like her, were commissioned to create intricate pieces for leading figures of the time. She sees her lacemaking practice as a way to highlight marginalized women's labor and their vastly undervalued skill across geography and time.

When it was complete, she walked the collar over to Columbia. "I felt like a dragon protecting a precious treasure," she said, "a treasure into which I had imbued part of myself." Soon after she delivered the gift, Kanagy-Loux received a note of thanks from the justice:

My chambers just gave me a photograph of the exquisite lace collar that awaits me on my return to the Court. I will wear it on my first week back, and often thereafter. With appreciation for a gift to treasure, Ruth Bader Ginsburg.

The lacemaking community mourned the loss of RBG deeply: "We really felt appreciated and seen by her," reflected Kanagy-Loux, "and recognized for the value of lace, which is so often overlooked in society today."

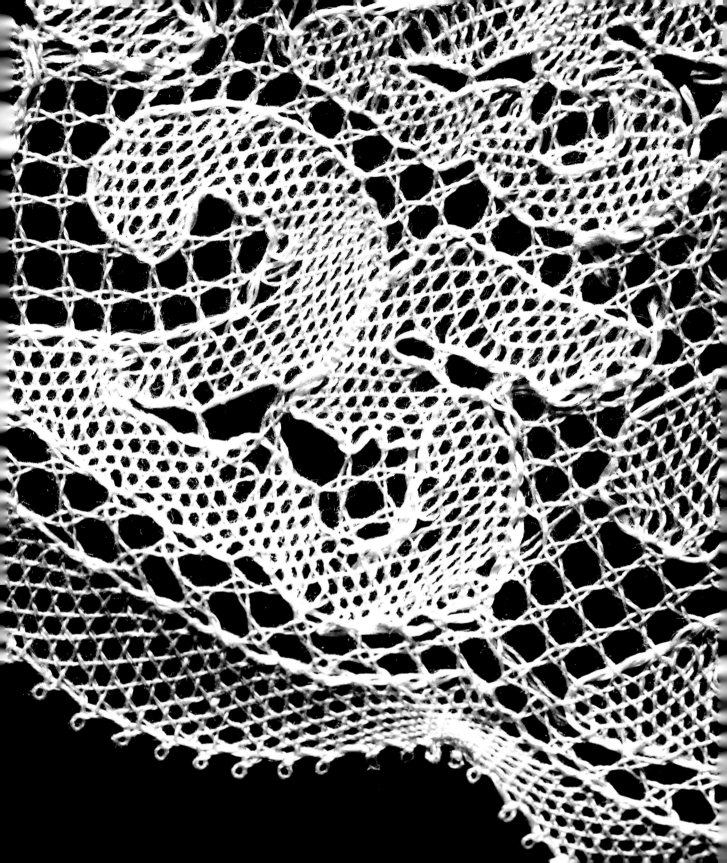

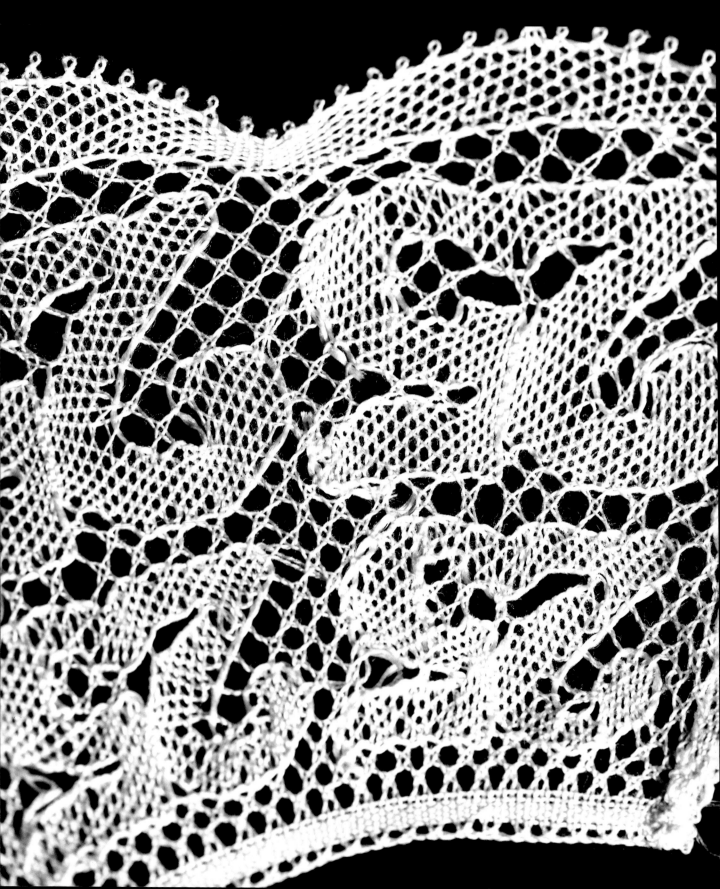

"I am very proud of my Columbia degree and politely declined to trade it in for one from Harvard when that became an option years later."

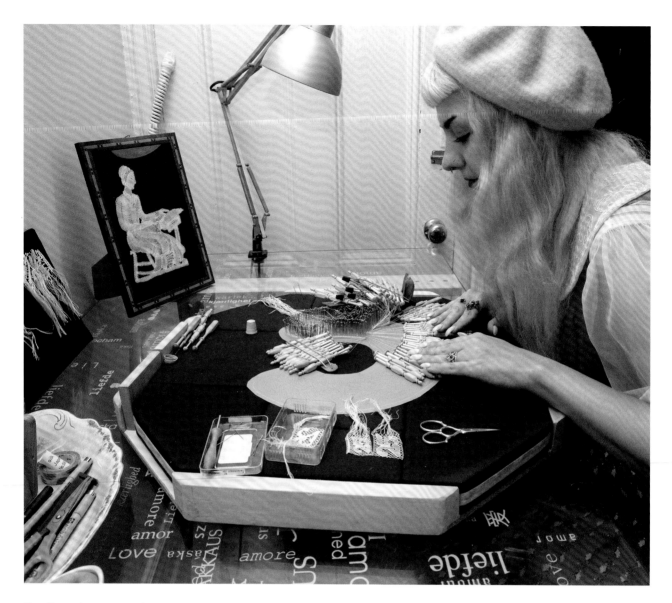

Elena Kanagy-Loux crosses and twists pairs of bobbins wound with cotton and silk thread following the pattern diagram pinned to the pillow. Pins are inserted as temporary scaffolding to hold tension and can be removed after an inch or more is completed to reveal the finished lace.

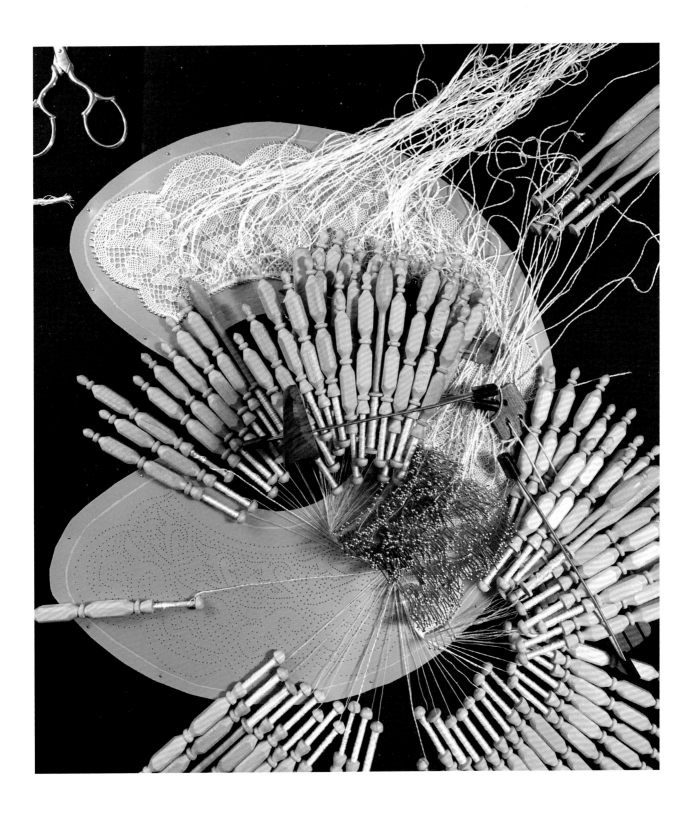

ELEGANT

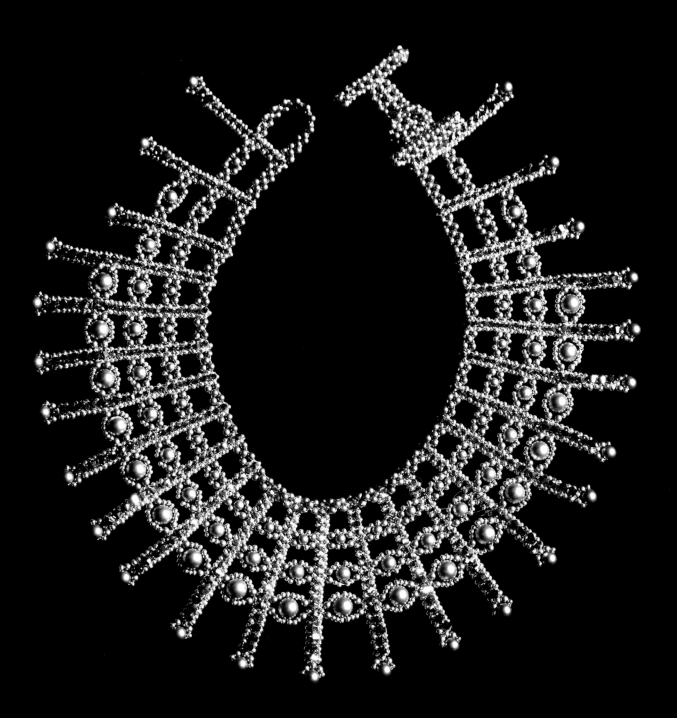

FEW DETAILS are known about this collar. RBG received it before the pandemic, in either late 2019 or early 2020. She described it simply as "elegant."

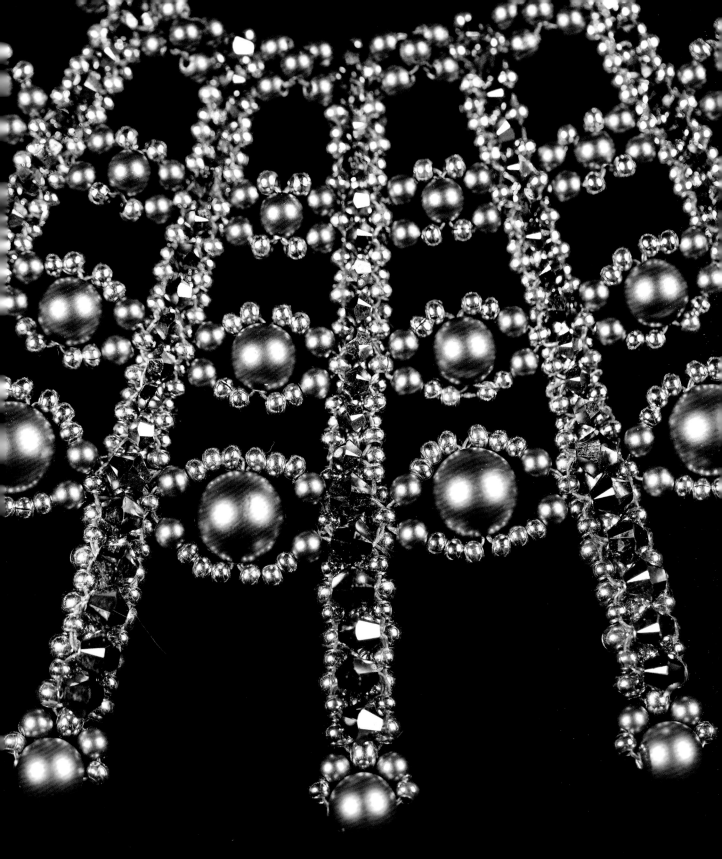

My mother was a hugely intelligent
woman. She emphasized two things. One
was that I should be a lady. And by
that she didn't mean fancy dress. What
she meant is, be in control of your
emotions and don't give way to anger,
to remorse, to envy, those emotions just
sap strength. . . . And her other message
was, be independent."

DELICATE

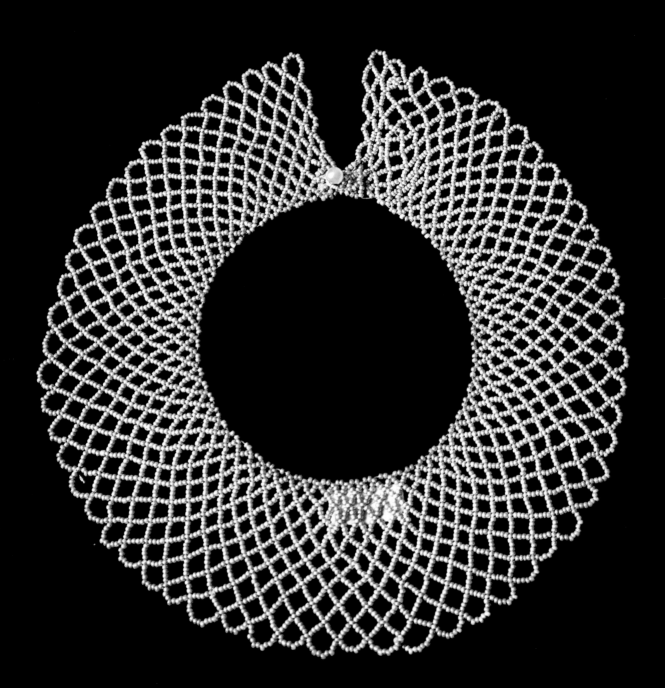

AN ARTIST MADE THIS DELICATE, beaded collar for Justice Ginsburg, which looks like a cousin to her favorite, white beaded collar from South Africa (see page 130). She wore it to President Donald Trump's Inauguration Day in 2017. According to Tessa Berenson of *Time*, "it barely withstood the day. Bundled amid the warm layers Ginsburg needed in the chilly weather, a strand on the collar broke and several beads fell off. (It was subsequently restrung.)"

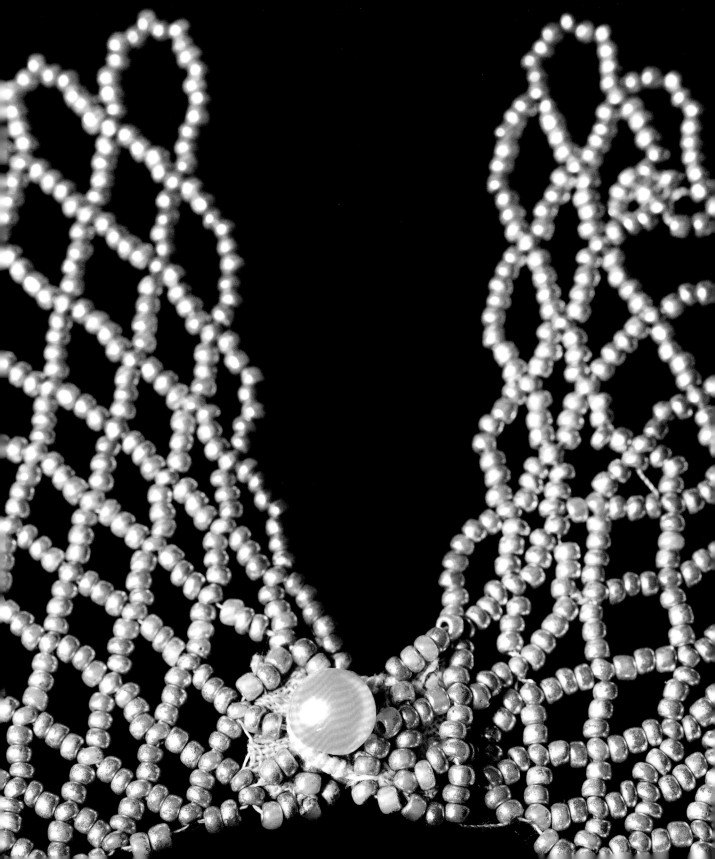

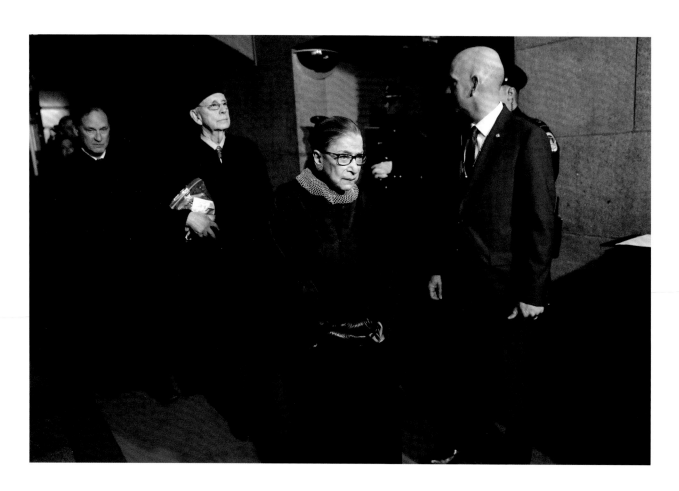

RBG arriving at President Donald
Trump's inauguration, January 20,
2017.

"The leadership style thought most effective in a civilized society is not the ruthless tough guy who forcibly imposes his will on others. Rather, the qualities that count most are the ability to conciliate among opposing factions and to foster the development of younger, less experienced people in return for their loyalties."

WILD

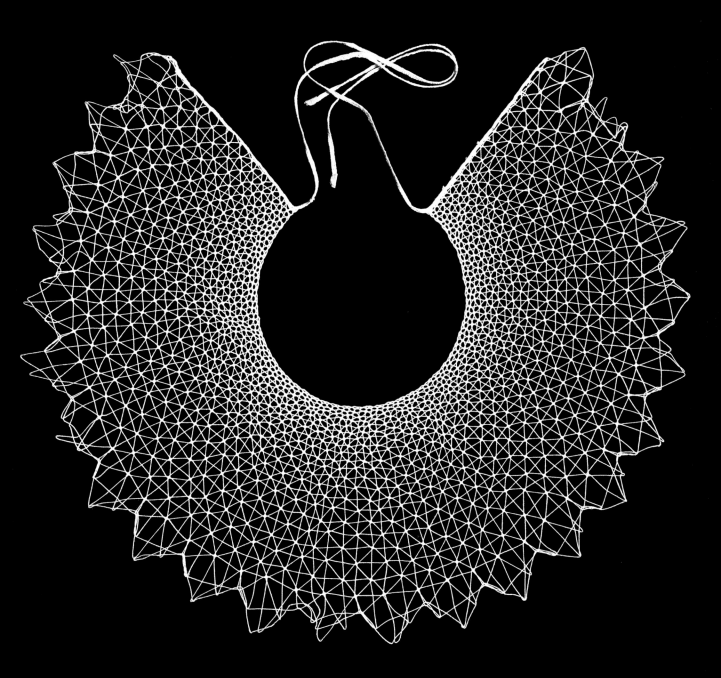

SOUTH AFRICAN ARTIST Kim Lieberman first heard of Justice Ruth Bader Ginsburg in the summer of 2018 when she was visiting Vulcano, an island off the coast of Sicily. While relaxing in a mud bath, she got to talking with another traveler, a woman from Seattle. The woman asked Lieberman what she did for a living: "I am a conceptual artist. I make lace," Lieberman told her. The traveler asked if she was familiar with RBG's collars and their symbolism. She was not, but the exchange planted a seed: Lieberman left the island determined to make a lace collar for Justice Ginsburg.

Lieberman first came to lace in 2007 as a way to express conceptual ideas with thread. The history of lace intrigued her. The craft originated in Europe, and although women—typically of few means and poorly paid—were the most gifted lacemakers, sumptuary laws prohibited them from wearing lace in the sixteenth and seventeenth centuries—only aristocracy and royalty were granted that aesthetic privilege. This was confounding to Lieberman: from her perspective, the concept of "royalty" had more to do with *true* leadership, morals, and ethics. In her series *Why the Collar?* Lieberman is inspired to reframe the history of lace by using antique or handmade collars to frame the heads of those whose lives embrace radical integrity. She focuses on individuals from Africa but extended the concept to include Justice Ginsburg. "Her reason for wearing a collar is a fit with my reason for making lace," explained Lieberman at the time. "Lace is not utilitarian, it's about presence, about who you are as a human being. I've been writing about this for years, and she's doing it. The concepts I explore within artworks, she's activating."

After returning to Johannesburg from Italy, she emailed retired South African justice Albie Sachs, whom she knew personally. He was involved in selecting the art collection for the Constitution Court during its inception, and one of Lieberman's artworks, *Constellations*, was chosen for that collection. Justice Sachs wrote back a few minutes later with an encouraging reply: he thought it was a wonderful idea. He and RBG, it turned out, shared a special friendship, and she revered the Constitution of the Republic of South Africa and its dedication to "democratic values, social justice, and fundamental human rights." Serendipitously, Justice Sachs and his wife, Vanessa, would be traveling to DC in November. He could hand deliver the collar to RBG in person if it was completed in time.

Lieberman got to work. Anchoring the design in complicated mathematical formulae and using twenty-three pairs of bobbins on twenty-two pins, she wove white silk thread into an intricate and stunning work of art. Lacemaking, which she describes as an "extreme craft"—historically made by tenacious hands and minds—is conceptually important to her: Lace is not frivolous or simply decorative—it is layered with history and meaning.

Lieberman prefers to work with "chaotic" or "wild" ground—"ground" in this context is the different geometric background patterns that hold together a piece of lace. The experience of making wild ground, which is a relatively unusual pattern in the lacemaking world, is chaotic—it is neither static nor orderly. The ground, she explains, "is not pinned at every juncture . . . It moves and pulls, and the whole piece feels connected to itself because of this." The title of the collar, *Wild*, reflects RBG's "wild integrity," which Lieberman defines as "somebody who is so hardcore, so radical, that they just persevered single-mindedly—or I should say expansive-mindedly—in doing the right thing."

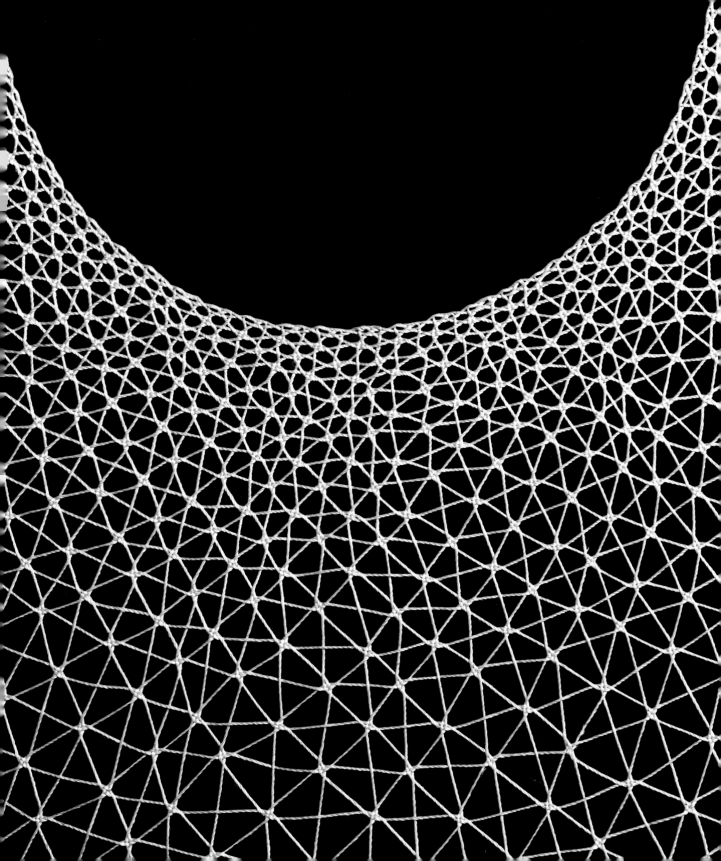

Albie Sachs and Kim Lieberman
with her collar *Wild*, 2018.

Using twenty-three pairs of
bobbins on twenty-two pins,
Lieberman deftly weaves
silk thread into an elaborate
design, 2018.

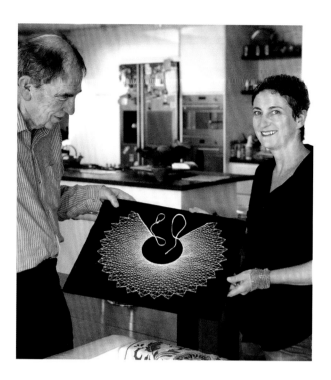

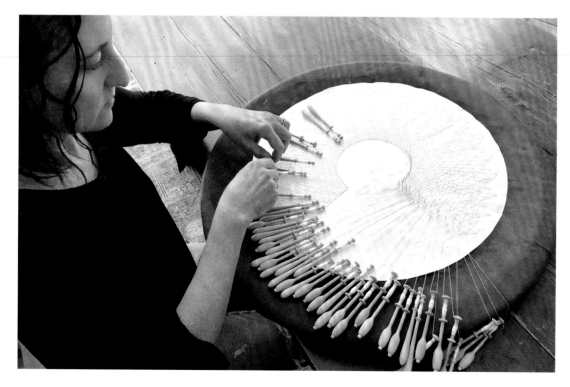

In November 2018, Justice Sachs brought the collar to RBG. He described the moment to Lieberman: "She gasped, literally gasped. She felt and touched the necklace, placed it round her neck, and put it back on the soft, dark cushion. She said she wasn't sure if she would wear it or display it as an artwork."

This was the first time Lieberman created a work of lace that was intended to be worn. Along with the collar, Lieberman included a letter to the justice explaining how she came to make the piece and these care instructions:

> *The lace collar was made to be worn.*
>
> *It should be handled with care.*
>
> *The lace closer to the neck is quite sturdy, while the lace at the edges, because it is more open, is more likely to move out of its pattern.*
>
> *If it does so it can carefully be moved back.*
>
> *The lace collar should not be washed.*

Wild resides at Georgetown University Law Center, where it will be on display as part of a permanent memorial to Justice Ginsburg and her husband, Marty.

LACELIKE SHELLS

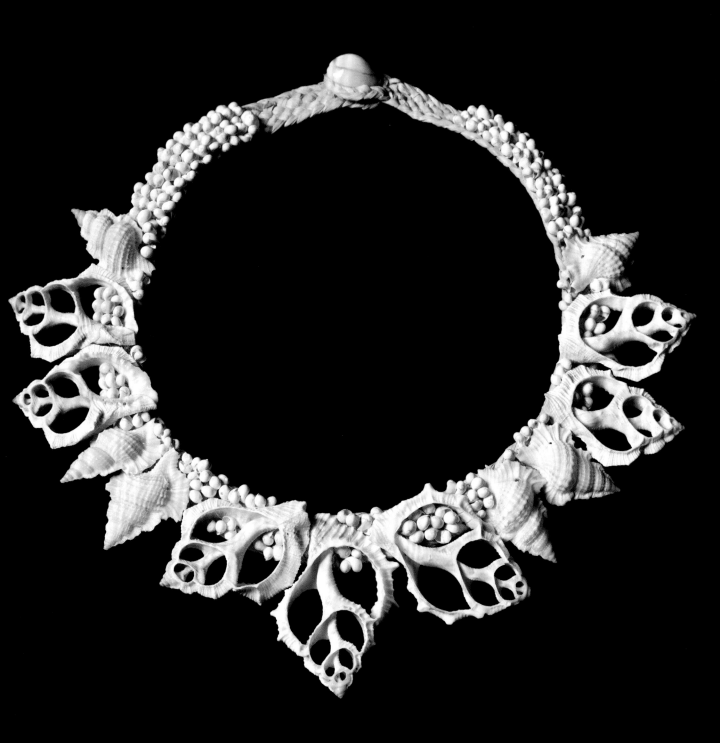

IN FEBRUARY 2017, RBG was a jurist-in-residence at the William S. Richardson School of Law at the University of Hawai'i at Mānoa. The justice had a crowded schedule during her visit: she taught a class; attended lunches and dinners in her honor; spoke to law students, faculty, lawyers, and federal judiciary; and made time to visit a local public school to speak to the young students there.

Grace Magruder, at the time a third-year law student studying territorial law and the Pacific Islands legal systems, volunteered to be one of the justice's escorts. She was the first person to greet RBG upon her arrival on campus: "Growing up in Washington, DC, I was used to seeing politicians travel with at least one advance staff, but Justice Ginsburg came with only her security detail. This really stood out to me given the significance of her position and her notoriety at the time. I chalked it up to be an example of her humility, practicality, work ethic, and independence." She also remembers that RBG was traveling with two very large and heavy bindors, which she later learned were cases that were being heard before the upcoming Supreme Court session. RBG spent a few hours studying them in an office at the law school before attending speaking events later that morning. "Even in Hawai'i, she never forgot her responsibilities to the Court."

Before the visit, Magruder had commissioned Rava Ray, a designer now based in Mooréa, French Polynesia, to create a necklace made of lacelike shells. Ray was attending Parsons School of Design at the time and was in the middle of finals; she warned her professors that she needed time to focus on this important commission. She made the base of the neckpiece out of woven raffia and fashioned the clasp out of a single cowrie shell and raffia loop. The large crosscuts are slices of murex shells and the smaller ones are mongo shells. On that February day, Magruder gave the shell collar to Justice Ginsburg, along with a note and a request: "I asked that if she ever had the opportunity to hear any cases related to our territories or freely associated states that she would wear this collar in honor of the peoples of American Samoa, Guam, the Commonwealth of the Northern Mariana Islands (CNMI), Micronesia, the Marshall Islands, Palau, Puerto Rico, and the US Virgin Islands. This region had always been important to me and an area that I felt did not get the attention within Washington, DC, that it deserved."

Justice Ginsburg's visit reminded Magruder of her fellow law students who were balancing the demands of law school with the pressures of motherhood at the time. It made her realize how much RBG's own family must have sacrificed for the country over the years: "Remembering her legacy makes me want to thank her family—especially her children and grandchildren for sharing their beloved mother and grandmother with the American people and for all the unseen sacrifices that they must have made in allowing her to do her work successfully up until the day she passed away."

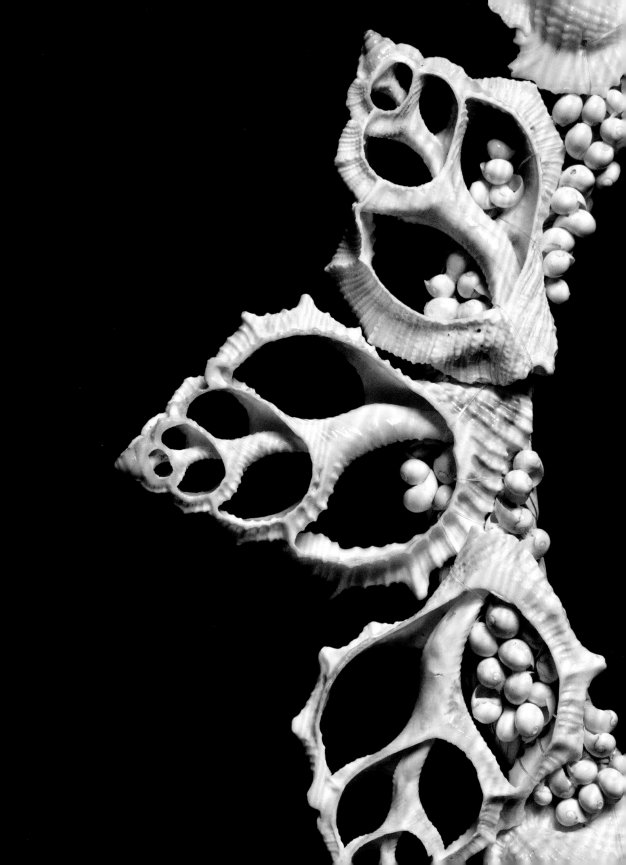

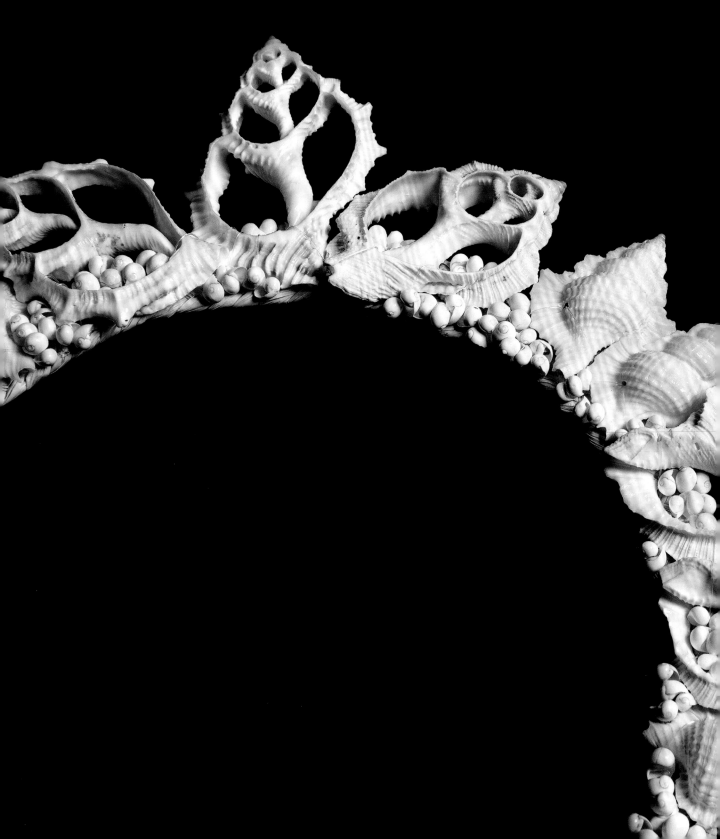

"Generalizations about the way women or men are—my life's

experience bears out—cannot guide me reliably in making

decisions about particular individuals. At least in the law, I have

found no natural superiority or deficiency in either sex. I was a

law teacher until I became a judge. In class or in grading papers

over seventeen years, and now in reading briefs and listening to

arguments in court for nearly twelve years, I have detected no

reliable indicator of distinctly male or surely female thinking—or

even penmanship."

FINAL

CONCENTRIC BANDS OF LACE form this crocheted collar, and a double frill cascades down the front. This style of neckwear was popular in the 1930s as a way of embellishing the neckline and front of a woman's dress. Pattern books published by thread and yarn companies of that era provided detailed instructions for making by hand similar collars, jabots, frills, and bows, and readers skilled in crochet could readily fashion these intricate accessories at home.

Justice Ginsburg wore this eminently dignified and graceful collar on the bench in her final term. It was also the collar she wore after her death on September 18, 2020, when she was lying in repose at the Supreme Court and in state at the Capitol. For two days, her flag-draped coffin was positioned under the portico at the top of the Supreme Court building's front steps. Supreme Court justices typically lie in repose for one day only, but two days were required to accommodate the thousands of mourners who journeyed far distances to pay their respects to the late Justice Ginsburg. On the third day, in a private ceremony, she lay in state in Statuary Hall in the US Capitol Building. RBG was given the dual distinction of being both the first woman and first Jewish American to lie in state in the nation's history.

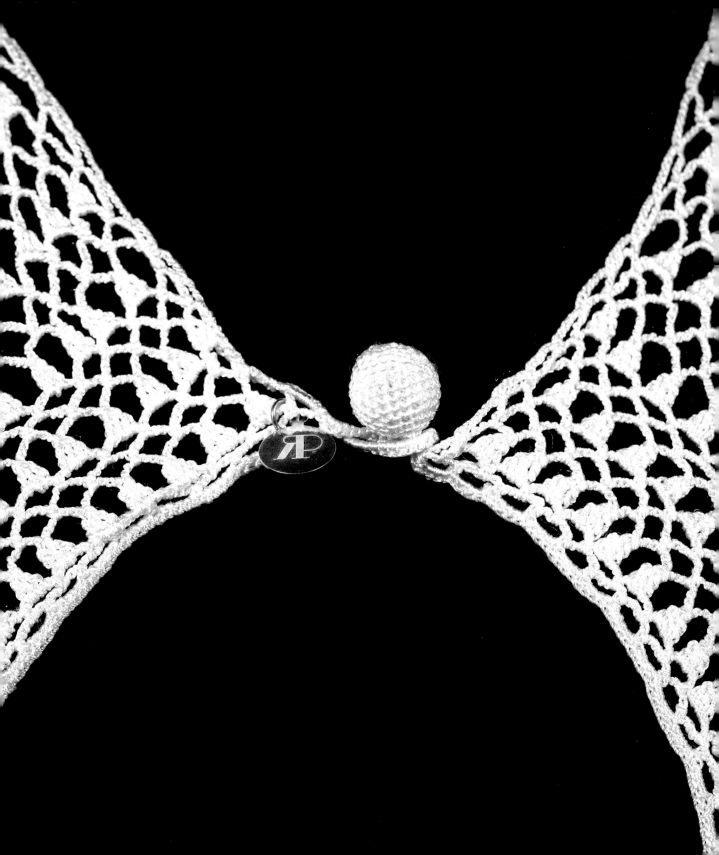

A makeshift memorial for RBG in front of the US Supreme Court, September 19, 2020.

Ginsburg's flag-draped casket is carried into Statuary Hall where she will lie in state at the US Capitol, Friday, September 25, 2020. She is the first woman and first Jewish American in US history to be given that honor.

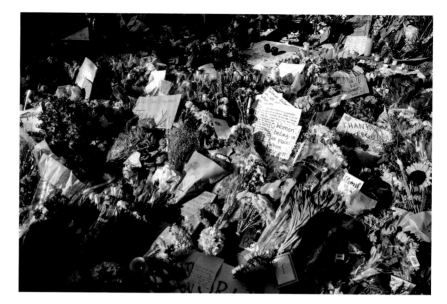

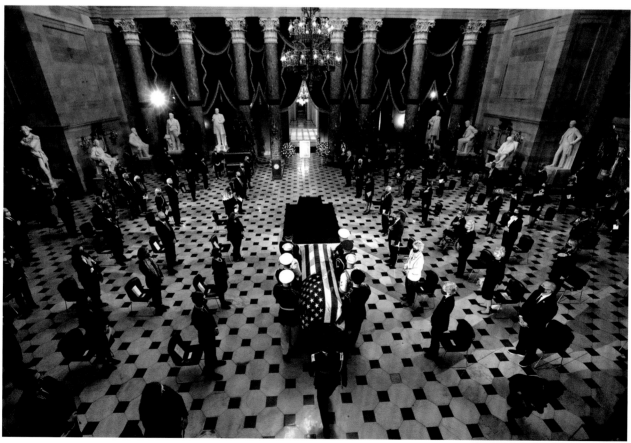

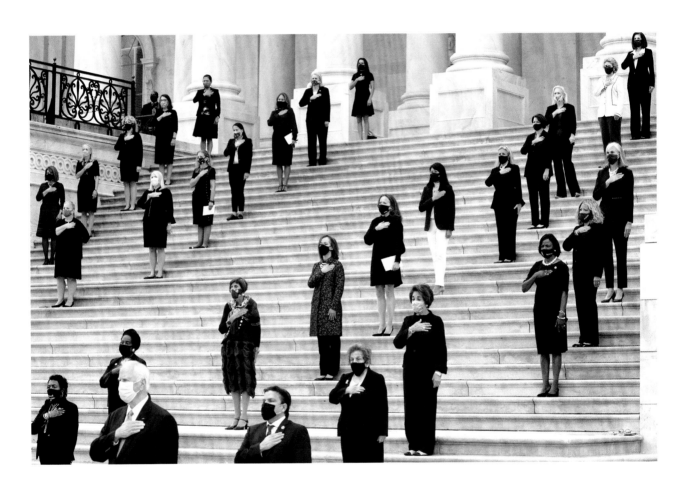

Female members of Congress
stand on the steps of the US
Capitol—with President Biden
at the front—and watch as
the hearse carrying the casket
of Justice Ruth Bader Ginsburg
departs, September 25, 2020.

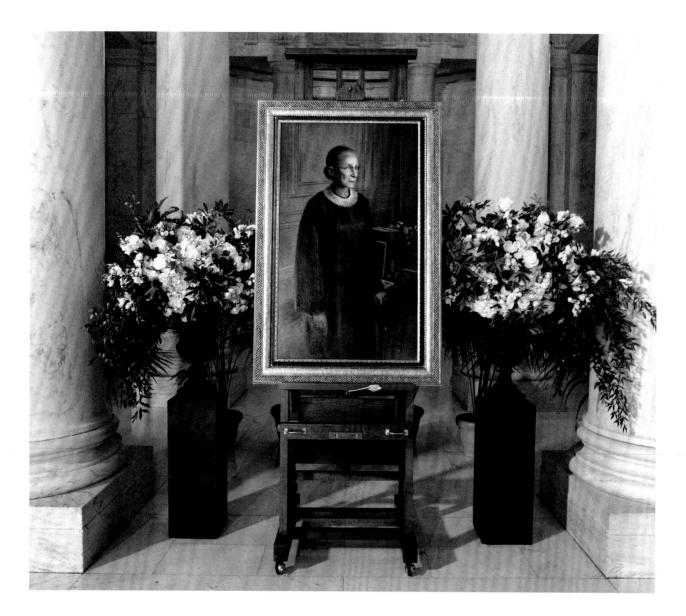

A 2016 portrait of RBG (wearing her favorite collar) by artist Constance P. Beaty is displayed in the Great Hall following a private memorial ceremony for her at the Supreme Court in Washington, DC, September 23, 2020.

"What is the difference between a New York City garment district bookkeeper and a Supreme Court Justice? One generation my life bears witness, the difference between opportunities open to my mother, a bookkeeper, and those open to me."

TIMELINE

1933 MARCH 15: At Beth Moses Hospital in Brooklyn, New York, Celia Bader gives birth to Joan Ruth. In kindergarten, Joan drops her first name to avoid confusion with the other Joans in the classroom and goes by her childhood nickname, "Kiki," at home.

1934 President Franklin D. Roosevelt nominates Florence Ellinwood Allen to the US Court of Appeals for the Sixth Circuit. Confirmed by the Senate, she is the first woman to sit on a federal appeals court bench.

1944 Supreme Court Justice William O. Douglas hires Lucile Lomen, the first female clerk at the Supreme Court.

At age eleven, Ruth is introduced to the opera when her aunt takes her to a condensed version of *La Gioconda*.

1950 Celia Bader dies two days before Ruth's graduation from James Madison High School in Brooklyn. Grieving the loss of her mother, Ruth does not attend the graduation ceremony.

Ruth begins her undergraduate studies at Cornell University. Her professors include Russian novelist Vladimir Nabokov, who instills in her an appreciation for writing and the importance of the choice and placement of words, and Robert Cushman, who teaches her constitutional law.

Ruth meets her future husband, Martin "Marty" Ginsburg, a fellow Cornell student, on a blind date.

Harvard Law School first admits female students.

1954 MAY 17: In the landmark case *Brown v. Board of Education of Topeka*, the Supreme Court rules unanimously that racial segregation of children in public schools is unconstitutional, reversing "separate but equal."

Ruth graduates from Cornell University.

JUNE 23: Ruth marries Marty Ginsburg in his family home in Rockville Centre, Long Island. Later that year, the young couple move to Fort Sill, Oklahoma, for Marty's army service.

1955 JULY 21: Birth of Jane Ginsburg, Ruth and Marty's first child.

1956 RGB starts her studies at Harvard Law School as one of nine female students in a class of roughly 500.

1958 Marty gets a job in New York City; Ruth transfers to Columbia University Law School.

1959 RBG graduates from Columbia at the top of her class, tied for first place.

Eager to help RBG secure a position as a law clerk, Harvard Law School professor Albert Sacks recommends her to Supreme Court Justice Felix Frankfurter. The Justice has never hired a woman, and decides not to interview her for the job.

RBG's mentor, law professor Gerald Gunther, helps her secure a position working for Judge Edmund Palmieri by promising the judge that if she doesn't perform well, he will replace her with another student, fully confident that RBG would excel. Gunther also promises that if Palmieri doesn't hire her, he will never recommend another star student to him again.

1963 RBG accepts a position at Rutgers teaching civil procedure, making her the second female full-time professor at the university. She learns that she is paid less than her male colleagues, and joins other female professors in filing—and eventually winning—an equal-pay suit.

JUNE 10: President John F. Kennedy signs the Equal Pay Act, the first law that focuses on equal pay for

women. At the time, women are paid fifty-nine cents for every dollar earned by a man. (In 2022, women are paid eighty-two cents for every dollar earned by a man.)

1964 JULY 2: President Lyndon Johnson signs into law the most sweeping civil rights legislation since Reconstruction. The Civil Rights Act prohibits discrimination in public places, provides for integration of schools and other public facilities, and makes employment discrimination illegal.

1965 RBG's first book, *Civil Procedure in Sweden*, coauthored with Swedish civil procedure scholar and judge Anders Bruzelius, is released in Sweden. She learned Swedish to collaborate on this book.

SEPTEMBER 8: Birth of James, Ruth and Marty's second child.

1967 AUGUST 30: The Senate confirms Thurgood Marshall, President Johnson's nominee, as the first African American justice of the Supreme Court with a 69–11 vote.

1969 RBG earns tenure from Rutgers.

1970 After being asked by law students to lead a seminar on women and the law, RBG teaches her first class on the subject. "In the space of one month," she said, "I read every federal decision that had ever been written in the area of gender and the law, and every law review article. There was barely anything—less than would be produced in two months nowadays." Preparing for and teaching that class shaped her professional course: less than three years later she was arguing *Frontiero v. Richardson* before the Supreme Court.

1971 JUNE 25: RBG writes her first brief for the Supreme Court in *Reed v. Reed*. The court's unanimous decision was the first time that the Supreme Court applied the Equal Protection Clause of the Fourteenth Amendment to strike down a law that discriminated against women.

1972 RBG becomes Columbia Law School's first female tenured professor.

She introduces the law school's first sex discrimination law seminar.

RBG cofounds the Women's Rights Project of the American Civil Liberties Union.

1973 JANUARY 17: RBG's first oral argument before the Supreme Court, in *Frontiero v. Richardson*, a landmark case for gender equality. On May 14, the court votes in favor of Frontiero, 8–1.

JANUARY 22: In the landmark case *Roe v. Wade*, the Supreme Court legalizes abortion throughout the United States. RBG is critical of the decision: she believes in a woman's right to choose but is concerned that the far-reaching decision tries to accomplish too much, too quickly, and that a more incremental approach would prove more durable over time. By invalidating dozens of states' abortion laws nationwide and basing the ruling on the right to privacy instead of on the Equal Protection Clause, the ruling is more vulnerable to challenges.

1974 RBG publishes *Sex-Based Discrimination: Text, Cases and Materials* with coauthors Kenneth M. Davidson and Herma H. Kay, the first casebook on the subject.

1980 President Jimmy Carter appoints RBG to the US Court of Appeals for the District of Columbia Circuit.

1981 AUGUST 19: President Ronald Reagan nominates Sandra Day O'Connor to the Supreme Court. On September 21, the Senate confirms Judge O'Connor by a vote of 99–0, making her the first woman to serve on the nation's highest court.

1993 JUNE 14: President Bill Clinton nominates RBG to the Supreme Court of the United States. On August 3, she is confirmed by a vote of 96–3.

1994 Justices Ginsburg and Scalia—dressed in costume and wearing wigs—are supernumeraries in Washington National Opera's production of *Ariadne auf Naxos*.

1996 JUNE 26: Joined by Justices Stevens, O'Connor, Kennedy, Souter, and Breyer, RBG writes the majority opinion for *United States v. Virginia*.

1999 SEPTEMBER 17: RBG undergoes surgery for colon cancer but doesn't miss a day on the bench.

2003 RBG and fellow justices Kennedy and Breyer play themselves in nonspeaking roles in the opera *Die Fledermaus* by Johann Strauss II.

2005 JULY 1: Justice Sandra Day O'Connor announces her retirement.

2007 APRIL 18: RBG reads her searing dissent from the bench after the Supreme Court upholds a federal law banning an abortion procedure in *Gonzales v. Carhart*.

MAY 29: RBG delivers another scathing dissent in *Ledbetter v. Goodyear*.

2009 FEBRUARY 5: RBG undergoes surgery for early-stage pancreatic cancer. She doesn't let her illness interrupt her work: within weeks, she is back on the bench.

MAY 26: President Barack Obama nominates Sonia Maria Sotomayor for the Supreme Court. On August 6, she is confirmed by the Senate in a vote of 68–31.

2010 JUNE 27: Marty Ginsburg dies from metastatic cancer.

AUGUST 5: President Barack Obama's nomination, Elena Kagan, is confirmed by the Senate in a 63–37 vote, making Justice Kagan the fourth female Supreme Court justice.

2012 Comedian Kate McKinnon impersonates RBG for the first time in a quick sketch for *Saturday Night Live*'s *Underground Festival: 2012 Election*. It would be three years until McKinnon impersonates her again, transforming her into a recurring character on *Saturday Night Live*.

2013 JUNE 25: Shana Knizhnik launches the *Notorious R.B.G.* Tumblr after RBG's exacting dissent in *Shelby County v. Holder* (5–4).

JUNE 26: The Supreme Court announces its majority decision (5–4) in *US v. Windsor*, striking down a key provision of the Defense of Marriage Act, allowing same-sex marriages to be recognized by the federal government.

AUGUST 31: RBG becomes the first Supreme Court justice to marry a same-sex couple when she officiates the marriage of Michael M. Kaiser and John Roberts.

2014 JUNE 30: In a 5–4 decision, the Supreme Court decides *Burwell v. Hobby Lobby Stores*. Describing it as "a decision of startling breadth," RBG reads a portion of her thirty-five-page dissent from the bench.

2015 Kate McKinnon's impersonation of RBG on *SNL*'s "Weekend Update" and her signature "Gins-burns"

are solidified as a memorable recurring character on the show. RBG is amused: "I like the actress who portrayed me . . . and I'd like to say 'Gins-burn!' sometimes to my colleagues."

JUNE 26: In a 5–4 decision, *Obergefell v. Hodges* legalizes same-sex marriage.

JULY 11: *Scalia/Ginsburg*, an opera written by Derrick Wang about the friendship of Justices Ginsburg and Scalia, premieres at the Castleton Festival, in Castleton, Virginia.

2016 **NOVEMBER 12:** RBG appears in the speaking role of the Duchess of Krakenthorp in Donizetti's opera *La Fille du Régiment* performed at the Washington National Opera.

2018 **APRIL 10:** At a naturalization ceremony at the New-York Historical Society, RBG administers the oath of allegiance to new citizens from more than fifty countries.

MAY 4: The documentary *RBG*, produced and directed by Julie Cohen and Betsy West, releases.

AUGUST 10: RBG marks twenty-five years on the Supreme Court.

2020 **SEPTEMBER 18:** Justice Ruth Bader Ginsburg dies at the age of eighty-seven. She is the first woman and first Jewish American to lie in state at the Capitol.

SEPTEMBER 26: President Trump nominates Amy Coney Barrett to the Supreme Court. On October 26, the Senate confirms Barrett's nomination in a vote of 52–48, with all Democrats and one Republican opposing her confirmation.

2022 **FEBRUARY 25:** President Joseph Biden nominates Ketanji Brown Jackson to the US Supreme Court. Jackson is the first African American woman to serve on the nation's highest court. On April 7, she is confirmed by the Senate in a vote of 53–47.

MARCH: The Ginsburg family donates RBG's dissent collar (see page 46), three additional collars (Lace, see page 26; Majority, see page 36; and Sunrise, see page 156), her judicial robe, and other culturally significant possessions to the Smithsonian's National Museum of American History. A few months later, RBG's Gilt Glass collar (see page 138), along with other personal items, is auctioned off at Bonhams. All proceeds from the sale are used to establish the Ruth Bader Ginsburg Endowment Fund.

JUNE 24: The Supreme Court overturns *Roe v. Wade*, reversing the constitutional right to abortion, which had been in place for nearly half a century. Protests erupt across the country.

2023 **AUGUST 10:** Marks the thirtieth anniversary of RBG taking her seat on the US Supreme Court.

Notes

THE ASSIGNMENT OF A LIFETIME | PAGES 8–13

"Women will have achieved": "A Conversation with Justice Ruth Bader Ginsburg," N.Y.C. Bar Association: *The Record* (Winter 2001): 18, https://www2.nycbar.org/Publications/record/winter01.1.pdf.

"The standard robe": Robert Barnes, "Justices Have Differing Views of Order in the Court," *Washington Post*, September 4, 2009, https://www.washingtonpost.com/wp-dyn/content/article/2009/09/03/AR2009090303790.html.

DISTINGUISHED | PAGES 14–25

"Nobody in those days": Bill Mears, "'Friendly' Court Uneasy About Changes on the Bench," CNN, n.d., https://www.cnn.com/2009/POLITICS/09/05/scotus.journal.court.change/index.html.

"[Ginsburg's] collars re-inject": Rhonda Garelick, "The Soft Power Impact of Ruth Bader Ginsburg's Decorative Collars," CNN, updated August 20, 2018, https://www.cnn.com/style/article/ruth-bader-ginsburg-collars/index.html.

"If I am notorious": Ruth Bader Ginsburg, Honorary Degree remarks, University of Buffalo, August 26, 2019, https://www.supremecourt.gov/publicinfo/speeches/Buffalo%20Honorary%20Degree%20Remarks%20August%202019.pdf.

"My advice is fight for the things": Irin Carmon, "Justice Ginsburg's Cautious Radicalism," *New York Times*, October 24, 2015, https://www.nytimes.com/2015/10/25/opinion/sunday/justice-ginsburgs-cautious-radicalism.html.

"Indeed, in my lifetime": *Hearing before the Committee on the Judiciary United States Senate*, 103rd Congress (June 20, 1993), https://www.govinfo.gov/content/pkg/GPO-CHRG-GINSBURG/pdf/GPO-CHRG-GINSBURG.pdf.

LACE | PAGES 26–35

"Lace is complicated to make": Victoria Thomas, "On the Breath of Angels," *Soolip*, n.d., https://www.soolip.com/the-sublime/hilmaafklint-pwpng.

"any gold or silver lace": Quoted in Ruthann Robson, *Dressing Constitutionally: Hierarchy, Sexuality, and Democracy from Our Hairstyles to Our Shoes* (New York: Cambridge University Press, 2013), 22.

"a warrior for justice": Morgan Hines, "'It is our turn to fight': Meghan Markle, Mariah Carey, Kate McKinnon Mourn Ruth Bader Ginsburg," *USA Today*, September 18, 2020, https://www.usatoday.com/story/entertainment/celebrities/2020/09/18/ruth-bader-ginsburg-mourned-mariah-carey-barbra-streisand-kerry-washington/5831576002/.

"a rock of righteousness": "Statement of Justice Stephen G. Breyer," *Statements from the Supreme Court Regarding the Death of Associate Justice Ruth Bader Ginsburg*, September 19, 2020, https://www.scotusblog.com/wp-content/uploads/2020/09/09.19.20-Press-Release-Statements-of-the-Supreme-Court-Regarding-the-Death-of-Associate-Justice-Ruth-Bader-Ginsburg-004.pdf.

"The judiciary is not a profession": Anna Moeslein, "Read Ruth Bader Ginsburg's 2012 Glamour Woman of the Year Speech," Glamour.com, September 18, 2020, https://www.glamour.com/story/ruth-bader-ginsberg-2012-glamour-woman-of-the-year-speech.

MAJORITY | PAGES 36–45

"I go through innumerable drafts": Joseph Kimble, ed., "Interviews with United States Supreme Court Justices," *The Scribes Journal of Legal Writing* (2010): 134, https://vdocuments.net/reader/full/the-scribes-journal-of-legal-writing.

"**Words could paint pictures**": Ruth Bader Ginsburg, "Ruth Bader Ginsburg's Advice for Living," *New York Times*, October 1, 2016, https://www.nytimes.com/2016/10/02/opinion /sunday/ruth-bader-ginsburgs-advice-for-living.html.

"**What we got back**": Edith Roberts, "Recalling Ruth Bader Ginsburg: A 'Precise Female,'" *Washington Post*, September 18, 2020, https://www.washingtonpost.com/opinions/ruth-bader-ginsburg-a-precise-female/2020/09/18/a1800d5c-0d0a-11e8-95a5 -c396801049ef_story.html.

"**I'd send her a draft**": Shannon Caturano, "Gay Couple Married by Ruth Bader Ginsburg Recalls Their Special Wedding Day," Spectrum News 1, September 19, 2020, https://spectrumlocalnews.com/nc/charlotte/news/2020/09/19/ gay-couple-married-by-ruth-bader-ginsburg-recalls-wedding-day.

"**Any profession has its jargon**": Kimble, ed., "Interviews with United States Supreme Court Justices," 141.

"**I think that law**": Ibid., 133.

"**I prefer and continue to aim**": Ruth Bader Ginsburg with Mary Hartnett and Wendy W. Williams, *My Own Words* (New York: Simon & Schuster, 2016), 212–13.

DISSENT | PAGES 46–55

"**This is my dissenting collar**": "Justice Ginsburg Exhibits Her Famous Collar Collection," interview by Katie Couric, Yahoo News, July 31, 2014, https://www.yahoo.com/entertainment/video/ justice-ginsburg-exhibits-her-famous-194517521.html.

"**This is my dissenting collar. It's black and grim**": Interview by Jane Pauley, *CBS Sunday Morning*, October 9, 2016, https://www.youtube.com/watch?v=FUlhXbRgBG4.

"**When a justice is of the firm view**": Ruth Bader Ginsburg, "Ruth Bader Ginsburg's Advice for Living," *New York Times*,

October 1, 2016, https://www.nytimes.com/2016/10/02/opinion/ sunday/ruth-bader-ginsburgs-advice-for-living.html.

"**to the intelligence of a future day**": Quoted in Melvin I. Urofsky, *Dissent and the Supreme Court: Its Role in the Court's History and the Nation's Constitutional Dialogue* (New York: Knopf, 2017), 12.

"**After 2006**": Jane Sherron De Hart, *Ruth Bader Ginsburg: A Life* (New York: Knopf, 2018), 424–25.

"**Every time I write a dissent**": "Justice Ruth Bader Ginsburg in Conversation with Bill Moyers," The Judith Davidson Moyers Women of Spirit Lecture, February 14, 2020, https://billmoyers.com/story/ transcript-justice-ruth-bader-ginsburg-in-conversation-with-bill-moyers/.

"**Four members of this Court**": Dissent, *Ledbetter v. Goodyear Tire & Rubber Co.*, 550 U.S. 618 (2007), reprinted in Ruth Bader Ginsburg with Mary Hartnett and Wendy W. Williams, *My Own Words* (New York: Simon & Schuster, 2016), 287.

"**Hubris is a fit word**": Dissent, *Shelby County v. Holder*, 570 U.S. 529 (2013), Justia, https://supreme.justia.com/cases/ federal/us/570/12-96/case.pdf.

"**Throwing out preclearance**": Ibid.

"**The arc of the moral universe**": Jane Sherron De Hart, *Ruth Bader Ginsburg* (New York: Knopf, 2018), 448.

"**all who share their beliefs**": Dissent, *Burwell v. Hobby Lobby Stores*, 573 U.S. 682 (2014) Justia, https://supreme.justia.com/cases/ federal/us/573/682/#tab-opinion-1970982.

"**Justice Ginsburg's dissents**": Rabbi Lauren Holtzblatt, "A Supreme Life, Remembering Ruth Bader Ginsburg," eulogy, CNN, September 25, 2020, http://www.cnn.com/ TRANSCRIPTS/2009/25/cnr.03.html.

"**My dissenting opinions**": Jeffrey Rosen, "Ruth Bader Ginsburg Is an American Hero," *The New Republic*,

September 28, 2014, https://newrepublic.com/article/119578/ruth-bader-ginsburg-interview-retirement-feminists-jazzercise.

"Dissents speak to a future age": Nina Totenberg, *Morning Edition*, NPR, May 2, 2002, https://www.npr.org/2002/05/02/1142685/ruth-bader-ginsburg-and-malvina-harlan.

ORAL ARGUMENTS I | PAGES 56–61

"an increased basic allowance": Frontiero v. Richardson, 411 U.S. 677 (1973), Justia, https://supreme.justia.com/cases/federal/us/411/677/.

"I ask no favor for my sex": Sarah Moore Grimké, quoted in Oral Arguments, Frontiero v. Richardson, 411 U.S. 677 (1973), Justia, https://supreme.justia.com/cases/federal/us/411/677/.

"I owe it all to my secretary": "Columbia Law Women's Association Discussion on Landmark Sex-Discrimination Cases," November 19, 1993, compiled in *Sincerely, Ruth Bader Ginsburg* (New York: The Trustees of Columbia University, 2018).

ORAL ARGUMENTS II | PAGES 62–69

"I wonder if Gloria Steinem": Letter to the editor, *New Brunswick Home News*, November 27, 1972, reprinted in Stephen Wiesenfeld, "My Journey with RBG," *Columbia Law Review* 121, https://columbialawreview.org/content/my-journey-with-rbg/.

"a classic example of the double-edged": *Weinberger v. Wiesenfeld*, 420 U.S. 636 (1975), Justia, https://supreme.justia.com/cases/federal/us/420/636/.

"gender-based distinction": Ibid.

"A skilled lawyer": Joseph Kimble, ed., "Interviews with United States Supreme Court Justices," *The Scribes Journal of Legal Writing* (2010): 134, https://vdocuments.net/reader/full/the-scribes-journal-of-legal-writing.

"I am a feminist!": Ruth Rubio-Marin, "'Notorious RBG': A Conversation with United States Supreme Court Justice Ruth Bader Ginsburg," *International Journal of Constitutional Law* 15, no. 3 (July 2017): 602–20, https://doi.org/10.1093/icon/mox053.

SCALLOP | PAGE 70–75

"The institution we serve": Ruth Bader Ginsburg, "Lighter Side of Life at the United States Supreme Court," pre-dinner remarks at New England Law, Boston, March 13, 2009, https://www.supremecourt.gov/publicinfo/speeches/viewspeech/sp_03-13-09#:~:text=All%20of%20us%20appreciate%20that,justice%20as%20best%20we%20can.

PEGASUS | PAGES 76–81

"something a warrior princess": Chloe Foussianes, "Ruth Bader Ginsburg's Newest Collar Was Sent to Her by a Fan," *Town & Country*, September 18, 2020, https://www.townandcountrymag.com/society/politics/a25461276/ruth-bader-ginsburg-new-collar-necklace-sent-by-a-fan/.

"For today's surprise": Ibid.

"When will there be enough": "A Conversation Between Justice Ruth Bader Ginsburg and Professor Robert A. Stein," University of Minnesota Law School, September 16, 2014, reprinted in *The Minnesota Law Review* 99, https://www.minnesotalawreview.org/wp-content/uploads/2014/12/Ginsburg_MLR1.pdf.

FAMILY | PAGES 82–91

"This whole design process": Email to the author, October 19, 2022.

"We felt that the collar": Caitlin Abber, "When Sarah and Miyako Met Ruth Bader Ginsburg," *The—M—Dash*, September 25, 2020, https://mdash.mmlafleur.com/our-ruth-bader-ginsburg-story/.

"For the design": Ibid.

"Like magic": Email to the author, October 19, 2022.

"I have been supportive": Stephen Labaton, "The Man Behind the High Court Nominee," *New York Times*, June 17, 1993, https://www.nytimes.com/1993/06/17/us/the-man-behind-the-high-court-nominee.html.

"People saw him as giving up": Joseph Pisani, "Two of Ruth Bader Ginsburg's Signature Collars to Be Auctioned for the First Time," *Wall Street Journal*, September 1, 2022, https://www.wsj.com/articles/two-of-ruth-bader-ginsburgs-signature-collars-to-be-auctioned-for-the-first-time-11661984083.

"He had enormous confidence": Ruth Bader Ginsburg with Mary Hartnett and Wendy W. Williams, *My Own Words* (New York: Simon & Schuster, 2016), 26.

"It was the closest I ever came": Abber, "When Sarah and Miyako Met Ruth Bader Ginsburg."

"To think": Email to the author, October 19, 2022.

"The idea of feminism": "Remarks for Wheaton College Commencement," May 17, 1997, https://live-wheaton-college-history.pantheonsite.io/wp-content/uploads/2019/08/Ginsburg_Remarks.pdf.

"When I was introduced": Jessica Weisberg, "Remembering Ruth Bader Ginsburg in Her Own Words," *Elle*, republished September 21, 2020, https://www.elle.com/culture/career-politics/interviews/a14788/supreme-court-justice-ruth-bader-ginsburg/.

STIFFELIO | PAGES 92–99

"It was an overwhelming experience": Ruth Bader Ginsburg, "My First Opera," Spring 2015, *Opera America Magazine*, reprinted in Medium, Jul 13, 2015, https://medium.com/@OPERAAmerica/justice-ruth-bader-ginsburg-and-justice-antonin-scalia-as-supernumeraries-in-washington-national-2d802e1d6f95.

"In preparation": Ibid.

"Toward the end of the opera": "Ginsburg and Scalia: 'Best Buddies,'" *All Things Considered*, NPR, February 15, 2016, https://www.npr.org/2016/02/15/466848775/scalia-ginsburgopera-commemorates-sparring-supreme-court-friendship.

"You need a respite": Joseph Kimble, ed., "Interviews with United States Supreme Court Justices," *The Scribes Journal of Legal Writing* (2010): 140, https://vdocuments.net/reader/full/the-scribes-journal-of-legal-writing.

"I had never heard": Ruth Bader Ginsburg as told to Frederick Allen, "A Love Supreme for Ruth Bader Ginsburg," *AARP The Magazine*, n.d., https://www.aarp.org/politics-society/history/info-2015/opera-a-love-supreme-for-bader-ginsburg.html#:~:text=I%20was%20a%20super%20once,two%20most%20perfect%20ever%20written.

"Most of the time": Ibid.

"Truth be told": Ruth Bader Ginsburg, remarks at Chautauqua Lawyers in Opera, Chautauqua, NY, July 29, 2013, https://www.supremecourt.gov/publicinfo/speeches/rbg_speech_chautauqua_ny_7-29-13.pdf.

ADVOCACY | PAGES 100–107

"year of action": Barack Obama, State of the Union Address, January 28, 2014, https://obamawhitehouse.archives.gov/the-press-office/2014/01/28/president-barack-obamas-state-union-address.

"My number one": Ruth Bader Ginsburg, Herma Hill Kay Memorial Lecture, Berkeley University, December 14, 2019, https://news.berkeley.edu/2019/12/14/berkeley-talks-transcript-ruth-bader-ginsburg/.

PRIDE | PAGES 108–115

"I was traveling in Ecuador": Todd Ruger, "Ginsburg Sports Rainbow Neckwear at Supreme Court," *Roll Call*, October 5, 2016, https://rollcall.com/2016/10/05/ginsburg-sports-rainbow-neckwear-at-supreme-court/.

"The nature of injustice": Anthony Kennedy, Majority Opinion, Obergefell v. Hodges, 576 U.S. _ (2015), Justia, https://supreme.justia.com/cases/federal/us/576/14-556/.

"I think it will be": Robert Barnes, "Ginsburg to Officiate Same-Sex Wedding," *Washington Post*, August 30, 2013, https://www.washingtonpost.com/politics/ginsburg-to-officiate-same-sex-wedding/2013/08/30/4bc09d86-0ff4-11e3-8cdd-bcdc09410972_story.html.

"I grew up in the shadow": Interview by Jane Eisner, Adas Israel, Washington, DC, *Forward*, February 5, 2018, https://forward.com/opinion/393687/jane-eisner-interviews-ruth-bader-ginsburg-transcript/.

"In recent years": Greg Stohr and Matthew Winkler, "Ruth Bader Ginsburg Thinks Americans Are Ready for Gay Marriage," Bloomberg.com, February 12, 2015, https://www.bloomberg.com/news/articles/2015-02-12/ginsburg-says-u-s-ready-to-accept-ruling-approving-gay-marriage-i61z6gq2#xj4y7vzkg.

WEDDINGS | PAGES 116–123

"I have had more": Ruth Bader Ginsburg, "Ruth Bader Ginsburg's Advice for Living," *New York Times*, October 1, 2016, https://www.nytimes.com/2016/10/02/opinion/sunday/ruth-bader-ginsburgs-advice-for-living.html.

"Marty was the first boy": Ruth Bader Ginsburg, Herma Hill Kay Memorial Lecture, Berkeley University, December 14, 2019, https://news.berkeley.edu/2019/12/14/berkeley-talks-transcript-ruth-bader-ginsburg/.

SUPREME | PAGES 124–129

"2020 has been rough": Barb Solish (@barbsolish), Twitter, August 31, 2020.

"Why is the younger generation": "'Notorious RBG': A Conversation with United States Supreme Court Justice Ruth Bader Ginsburg," *International Journal of Constitutional Law* 15, no. 3 (July 2017): 602–20, https://academic.oup.com/icon/article/15/3/602/4582632.

"I will confess": Ruth Bader Ginsburg, "Remarks for Wheaton College Commencement," May 17, 1997, https://live-wheaton-college-history.pantheonsite.io/wp-content/uploads/2019/08/Ginsburg_Remarks.pdf.

FAVORITE | PAGE 130–137

"deficit of trust": Barack Obama, State of the Union Address, January 27, 2010, https://obamawhitehouse.archives.gov/the-press-office/remarks-president-state-union-address.

"After Sandra left": Interview by Jan Smith, Smithsonian National Portrait Gallery, n.d., https://npg.si.edu/exhibit/fourjustices/pop-ups/video_ginsburg.html.

"a deliberate attempt": Interview by Al-Hayat TV, January 30, 2012, https://www.memri.org/tv/us-supreme-court-justice-ruth-bader-ginsburg-egyptians-look-constitutions-south-africa-or-canada.

GILT GLASS | PAGE 138–143

"If you want to be a true professional": Kathleen J. Sullivan, "U.S. Supreme Court Justice Ruth Bader Ginsburg Talks About a Meaningful Life," Stanford University Rathbun Lecture, February 6, 2017, https://news.stanford.edu/2017/02/06/supreme-court-associate-justice-ginsburg-talks-meaningful-life/.

ANU | PAGES 144–149

"I would be glad": Daniel Estrin, "Ruth Bader Ginsburg's Iconic Collar to Go on Display in Israel," NPR, September 29, 2020, https://www.npr.org/sections/death-of-ruth-bader-ginsburg/2020/09/29/918163074/ginsburgs-iconic-collar-to-go-on-display-in-israel#:~:text=27%2C%20Ginsburg%20replied%20on%20Supreme,It%20was.

"She was the first person I saw": Shulamith Bahat, interview with author, October 1, 2021.

"My heritage as a Jew": Ruth Bader Ginsburg, National Commemoration of the Days of Remembrance, April 22, 2004, https://www.supremecourt.gov/publicinfo/speeches/viewspeech/sp_04-22-04.

PLEATED | PAGES 150–155

"My room has the only": Sam Sokol, "In Jerusalem, Ruth Bader Ginsburg Celebrates Her Commitment to Tikkun Olam," *Jewish Standard*, July 12, 2018, https://jewishstandard.timesofisrael.com/in-jerusalem-ruth-bader-ginsburg-celebrates-her-commitment-to-tikkun-olam/.

SUNRISE | PAGES 156–163

"I thought it was a grand idea": Liz Robbins, "Justice Ginsburg Urges New Citizens to Make America Better," *New York Times*, April 10, 2018, https://www.nytimes.com/2018/04/10/nyregion/supreme-court-ruth-bader-ginsburg-naturalization-ceremony.html.

"My fellow Americans": Ruth Bader Ginsburg, Remarks at the New-York Historical Society, April 10, 2018, https://www.supremecourt.gov/publicinfo/speeches/Remarks%20for%20April%2010%20Naturalization%20Ceremony_edited%20header.pdf.

"We are a nation": Ibid.

TWENTY-FIFTH ANNIVERSARY | PAGES 164–171

"I felt like a dragon": Elena Kanagy-Loux, "A Lace Collar for Ruth Bader Ginsburg," *Bulletin of the International Organization of Lace* 41, no. 2 (Winter 2021): 32–33.

"My chambers just gave me": Ibid.

"We really felt appreciated": Cecilia Nowell, "An Interview with Elena Kanagy-Loux, the Woman Who Made One of RBG Lace

Collars," *Teen Vogue*, September 25, 2020, https://www.teenvogue
.com/story/elena-kanagy-loux-ruth-bader-ginsburg-lace-collar.

"I am very proud": Ruth Bader Ginsburg, Remarks at Columbia
Law School Alumni Association reception and dinner, Honolulu,
August 5, 1980; compiled in *Sincerely, Ruth Bader Ginsburg*
(New York: The Trustees of Columbia University), 2018.

ELEGANT | PAGES 172–177

"My mother was a hugely intelligent": Interview
by Jane Eisner, Adas Israel, Washington, DC, *Forward*,
February 5, 2018, https://forward.com/opinion/393687
/jane-eisner-interviews-ruth-bader-ginsburg-transcript/.

DELICATE | PAGES 178–185

"it barely withstood the day": Tessa Berenson, "Portraits of
Ruth Bader Ginsburg's Favorite Collars and the Stories Behind
Them," *Time*, November 24, 2020, https://time.com/5914834
/ruth-bader-ginsburg-collars/.

"The leadership style": Ruth Bader Ginsburg, 1992
Commencement Speech, Lewis & Clark Law School, republished
at https://law.lclark.edu/live/news/44348-justice-ruth-bader
-ginsburgs-1992-commencement.

WILD | PAGES 186–193

"Her reason for wearing": Gillian Klawansky, "Weaving the
Threads," *South African Jewish Report*, December 6, 2018,
https://www.sajr.co.za/weaving-the-threads/.

"democratic values, social justice": Preamble to South Africa's
Constitution, Constitute Project, https://www.constituteproject.org/
constitution/South_Africa_2012.pdf?lang=en.

"extreme craft": Kim Lieberman biography,
https://www.kimlieberman.com/.

"is not pinned": Kim Lieberman, "Reframing: The History of Lace:
Lace from Europe, Lace in Africa," 2015.

"somebody who is so hardcore": Karen Schimke,
"How a Silk Collar Connected Ruth Bader Ginsburg to
South Africa," *Daily Maverick*, September 24, 2020,
https://www.dailymaverick.co.za/article/2020-09-24-how-a
-silk-collar-connected-ruth-bader-ginsburg-to-south-africa/.

"She gasped": Klawansky, "Weaving the Threads."

"The lace collar was made": "Care of Lace Collar,"
instructions from Kim Lieberman to Ruth Bader Ginsburg, n.d.

LACELIKE SHELLS | PAGES 194–199

"Growing up in Washington, DC": Emails to the author,
January 1, 2022 and March 16, 2023.

"Even in Hawai'i": Ibid.

"I asked that if she ever": Ibid.

"Remembering her legacy": Email to the author, January 1, 2022.

"Generalizations about the way": Ruth Bader
Ginsburg, 1992 Commencement Speech, Lewis & Clark
Law School, republished at https://law.lclark.edu/live
/news/44348-justice-ruth-bader-ginsburgs-1992-commencement.

FINAL | PAGES 200–207

"What is the difference": Ruth Bader Ginsburg with
Mary Hartnett and Wendy W. Williams, *My Own Words*
(New York: Simon & Schuster, 2016), 85.

TIMELINE | PAGES 208–213

"In the space of one month": "Justice Ruth Bader Ginsburg:
A 'Lady' Who Led the Fight for Gender Equity," *Duke Law
Magazine* 23, no. 1 (Spring 2005): 8, https://law.duke.edu/news/pdf
/lawmagspr05.pdf.

"a decision of startling breadth": Ruth Bader Ginsburg, Dissent,
Burwell v. Hobby Lobby Stores, 573 U.S. 682 (2014), Justia,
https://supreme.justia.com/cases/federal/us/573/682/#tab-opinion
-1970982.

"I like the actress": Nina Totenberg, "Justice Ruth Bader
Ginsbur g Reflects on the #MeToo Movement: 'It's About
Time,'" *Morning Edition*, January 22, 2018, https://www.npr
.org/2018/01/22/579595727/justice-ginsburg-shares-her-own
-metoo-story-and-says-it-s-about-time.

Acknowledgments

We are grateful to Vince Aletti, who introduced us several years ago and sensed that we would connect and collaborate well together—his intuition was absolutely right. Our great thanks to Sara Neville, our brilliant and insightful editor, who shaped and guided this book with the steadiest editorial hand. We count ourselves very lucky to work with Susan Raihofer, our literary agent, who believed in us and the project from the start and is a dream collaborator in every way. We are indebted to the Clarkson Potter team for taking such good care of this book: Jennifer Wang, who created a design that captures the elegance and power of RBG's collars and jabots so perfectly, production editor Christine Tanigawa, production manager Kelli Tokos, compositors Hannah Hunt and Merri Ann Morrell, copy editor L. J. Young, proofreaders Janet Renard and Kim Lewis, publicist Lauren Chung, and marketer Joey Lazada.

We are thankful to Tessa Berenson for her diligent reporting for the original *Time* piece, "Portraits of Ruth Bader Ginsburg's Favorite Collars and the Stories Behind Them," which provided important context, and Tanya Heinrich and Bridget McCarthy for their valuable editorial reviews. Our gratitude, also, to: Katie Allen, Shulamith Bahat, Nina Barnett, Oliver Barnett, Erin Beasley, Anna Butel, Gerard and Mary Calabaza, Josefine Cardoni, Celia Foy Castillo, Maria Costa, Kate Kinstler Fuertes, Jane Ginsburg, Nancy Goldfarb, Mary Hartnett, Elena Kanagy-Loux, Irina Kandarasheva, Ronette Kawakami, Sebastian Kim, Dana Kinstler, Sarah LaFleur, Kim Lieberman, Arthur Lien, Tyler Lopez, Grace Magruder, Whitney Maxwell, Patricia McCabe, Miyako Nakamura, Diane Harrison Ogawa, Claire Pingel, Matt Roth, Justice Albie Sachs, Annalisa Shanks, Leona Shanks, Scott Suchman, John Tomasicchio, Kara Van Woerden, and Sarah Woessner.

We would like to thank Justice Ginsburg for bringing hope and justice into this world, and for reminding us through her tenacious work that "real change, enduring change, happens one step at a time."

My great thanks to *Time* magazine and director of photography Katherine Pomerantz for her vision and for trusting me with this incredible assignment. I couldn't have done this book or anything else without the love and support of my family: my husband, guardian angel, photo assistant (on this mission), and father of my children, Eran Bendheim; my sweet children, Emmanuelle and Eden; my wonderful parents, Dalia and Mani.

Many thanks also go to the Supreme Court and its wonderful people, Julie Castellano, Edwynn Houk, Kat Kiernan, Alexis Dean, Julia Hartshorn, and the entire Houk gallery, Paul Cousins and Ilford, Rebecca Shaykin and the Jewish Museum, Emily Leonardo and Howard Bernstein and Atrbute, Jeffrey Kane and LTI, and Jeff Hirsch and Fotocare. And also to Matthew Baum, Maya Benton, Karen Dalzell, Michael Foley, Corinne Hill, Neil Kramer, Gillian Laub, Joanna Milter, and Kathy Ryan.

—EC

Deepest thanks to Deb Aaronson, Meghan Bennett, Megan Carey, Kate Fitzpatrick, Maggie Flowers, Christina George, Kate Mapother, Bridget McCarthy, Rebecca Morrill, Lisa Nilsson, William Norwich, Phil Palladino, Nellie Perera, Emilia Pisani, Elizabeth Redwine, Rich Remsberg, Diane Sullivan, Chris, Lara, Maceo, and Manu Thompson, and Leah Williams; to my mother, Beverly, my late father, Lawrence, my sister and brother-in-law, Rachel and Leon, my niece and nephew, Eleanor and Isaac—and to John Thompson for his love and encouragement. —SB

Photograph Credits

4: © Sebastian Kim

6–7: Reuters/Jonathan Ernst/Alamy

19: (top) National Portrait Gallery, Smithsonian Institution, gift of Everett Raymond Kinstler © Estate of Everett Raymond Kinstler; (bottom) Collection of the Supreme Court of the United States

30: Eraza Collection/Alamy

31: Collection of the Supreme Court of the United States

41: (top) Chip Somodevilla/Getty Images; (bottom) Reuters/Jonathan Ernst/Alamy

51: © Art Lien

80: (top) Collection of the Supreme Court of the United States; (bottom) Chip Somodevilla/Getty Images

87: (top) Mark Reinstein/Getty Images; (bottom) Collection of the Supreme Court of the United States

88–90: Images courtesy of M.M.LaFleur

96: © Scott Suchman

99: Karin Cooper/Getty Images

104: © Matt Roth

105: Bill Clark/Getty Images

120: Collection of the Supreme Court of the United States

134: Getty Images

135: The Washington Post/Getty Images

136: National Portrait Gallery, Smithsonian Institution. gift of Annette P. Cumming © Estate of Nelson Shanks

137: The Washington Post/Getty Images

139–42: Copyright © 2022 Bonhams & Butterfields Auctioneers Corp. All Rights Reserved.

154: (top) Jeffrey Markowitz/Getty Images; (bottom) © Eran Bendheim

162: Spencer Platt/Getty Images

163: (top) Courtesy of Celia Foy Castillo; (bottom) Collection of the Supreme Court of the United States

170–71: Courtesy of Columbia Law School. Photo by Sam Hollenshead.

182: AFP/Getty Images

190: (top) © Oliver Barnett; (bottom) © Nina Barnett

204: (top) Samuel Corum/Getty Images; (bottom) Chip Somodevilla/Getty Images

205: Bloomberg/Getty Images

206: UPI/Alamy

ORIGINAL TITLES OF ELINOR CARUCCI'S PHOTOGRAPHS

Distinguished: Early in Ginsburg's time on the Supreme Court, 2020

Lace: One of Ginsburg's Original Lace Jabots, 2020

Majority: Majority Collar, 2020

Dissent: Dissent Collar (2012), 2020

Oral Arguments I: Gift from her October Term 2016 Clerks, 2020

Oral Arguments II: Oral Arguments Collar, 2020

Scallop: Court Collar, 2020

Pegasus: Collar worn in official photo of all nine justices after Justice Brett Kavanaugh joined the Court (2018), 2020

Family: Husband Marty Ginsburg words, "It's not sacrifice, it's family," 2020

Stiffelio: *Stiffelio* Collar, the Metropolitan Opera, 2020

Advocacy: 2015 State of the Union Collar, 2020

Pride: Pride Collar (2016), 2020

Weddings: Weddings Collar, 2020

Supreme: South America Collar: the last collar Ginsburg wore in her lifetime, at a wedding she officiated on August 30, 2020

Favorite: South African Collar, Ginsburg's Favorite Collar, Worn in her Official Portrait, 2020

Anu: A lace collar, gift of Ruth Bader Ginsburg to ANU, The Museum of the Jewish People, Tel Aviv, Israel, 2021

Pleated: Ruth Bader Ginsburg gift to the National Museum of American Jewish History, Philadelphia, PA, 2021

Sunrise: International Women's Forum at the New Mexico Supreme Court, 2020

Twenty-Fifth Anniversary: Columbia Law School 25th Anniversary on the Supreme Court gift, 2022

Elegant: "Elegant" Collar, 2020

Delicate: Donald Trump's Inauguration Day Collar (2017), 2020

Wild: Wild lace collar from Johannesburg by artist Kim Lieberman, 2021

Lacelike Shells: University of Hawaii, Jurist in Residence Collar (2017), 2020

Final: Final term and lying in state at the Capitol, September, 2020

About the Authors

ELINOR CARUCCI is an award-winning fine art photographer whose work has been included in solo and group exhibitions worldwide and can be seen in *The New York Times Magazine*, *The New Yorker*, *Time*, *W*, and dozens of other publications. She has published four monographs and her photographs are part of prestigious museum collections, including the Museum of Modern Art, the Brooklyn Museum of Art, the Jewish Museum, and the Houston Museum of Fine Art. She is on the faculty at the School of Visual Arts and is represented by the Edwynn Houk Gallery in New York City.

SARA BADER is an editor and writer. She has worked as an acquisitions editor for Princeton Architectural Press and as a senior editor for Phaidon. In addition to editing visual culture books, she has conceived and researched quotation compilations, including *Art Is the Highest Form of Hope* and *Every Day a Word Surprises Me*. She coauthored *Out of the Wreck I Rise* (2016) and recently published *The Book of Pet Love & Loss*, a compendium of quotations by legendary cultural figures.

Published in the United States by Clarkson Potter/Publishers, an
imprint of the Crown Publishing Group, a division of Penguin Random
House LLC, New York.
ClarksonPotter.com

CLARKSON POTTER is a trademark and POTTER with colophon is a
registered trademark of Penguin Random House LLC.

Library of Congress Cataloging-in-Publication Data has been
applied for.

ISBN 978-0-593-58078-3
Ebook ISBN 978-0-593-58079-0

Additional credits appear on pages 221–222, which constitute a
continuation of this copyright page.

Editor: Sara Neville
Designer: Jen Wang
Production editor: Christine Tanigawa
Production manager: Kelli Tokos
Compositors: Merri Ann Morrell, Hannah Hunt
Copyeditor: L. J. Young
Proofreaders: Janet Renard, Kim Lewis
Publicist: Lauren Chung | Marketer: Joey Lozada

Printed in China

10 9 8 7 6 5 4 3 2 1

First Edition